A Guide to
Victorian & Edwardian Portraits

Peter Funnell and Jan Marsh

National Portrait Gallery, London
in association with the National Trust

Published in Great Britain by
National Portrait Gallery Publications
National Portrait Gallery
St Martin's Place
London WC2H 0HE

In association with the
National Trust
Heelis, Kemble Drive
Swindon, Wiltshire SN2 2NA
www.nationaltrust.org.uk

For a complete catalogue of current
publications please write to the National
Portrait Gallery at the address above, or visit
our website at www.npg.org.uk/publications

ISBN 978 1 85514 435 4

A catalogue record for this book is
available from the British Library.

10 9 8 7 6 5 4 3 2 1

Head of Publications: Celia Joicey
Managing Editor: Christopher Tinker
Editor: Claudia Bloch
Design: Thomas Manss & Company
Production Manager: Ruth Müller-Wirth
Printed and bound in Hong Kong

Picture credits

Front cover
Detail from **Ellen Terry (*Choosing*)** by George
Frederic Watts, *c*.1864, see p.33.

Back cover
Ellen Terry (*Choosing*) by George Frederic
Watts, *c*.1864, see p.33.

Inside front cover
Nancy Astor by John Singer Sargent, 1908–9,
see p.58.

Inside back cover
Charles Darwin by John Collier, 1883, see p.27.

The publisher would like to thank the
copyright holders for granting permission
to reproduce works illustrated in this book.
Every effort has been made to contact the
holders of copyright material, and any
omissions will be corrected in future editions
if the publisher is notified in writing.

All pictures copyright © 2011 National
Portrait Gallery unless otherwise stated.

p.4 Acquired with the assistance of the
National Heritage Memorial Fund (1984)
NTPL/John Hammond; p.5 NTPL/John
Hammond; p.8 NPG P114 Given by Dr
Robert Steele, 1939; p.9 NPG 2447 Given
by Roger Fry, 1930; p.11 NPG 835 Given by
Sir William Agnew, 1st Bt, 1890; p.12 (top)
NPG P56 Given by Helen Macgregor, 1978;
(bottom) NTPL/John Hammond; p.13 NTPL/
Derrick E. Witty/The Mander Collection;
p.14 NPG 1406 Given by the executors of
the sitter's estate, 1905; p.15 NPG 1078
Given by George Frederic Watts, 1897; p.17
NPG 6612 Purchased through The Art Fund
and the Heritage Lottery Fund, 2002; p.18
NPG 4252 Given by The Art Fund, 1962;
p.19 NPG 1630 Given at the wish of the
sitter, 1911; p.22 (both) NTPL/Nick Carter;
p.23 NPG P112 Given by Mr and Mrs A.J.W.
Vaughan, 1972; p.24 NPG P660 Purchased
with help from The Art Fund, 1996; p.25 NPG
P4 Given by M.K. Lucas, 1927; p.26 NTPL/
Derrick E. Witty; p.27 NPG 1024 Given by the
sitter's son, William Erasmus Darwin, 1896;
p.30 NPG x11905 Given by Edgar Thomas
Holding, 1934; p.31 NPG 2911 Bequeathed
by Sir William Schwenck Gilbert, 1937; NPG
1325 Bequeathed by Sir Arthur Seymour
Sullivan, 1902; p.32 NPG 1560 Given by
Dame Ellen Terry, 1910; p.36 NPG 1172 Tate
2011, on loan to the National Portrait Gallery,
London; p.38 NPG 1898, 1899 Given by
Florence Barclay, 1921; p.39 NPG P3 Given
by the sitter's son, Sir Mayson Beeton, 1932;
p.40 NPG P991(7) Purchased jointly with the
National Museum of Photography, Film and
Television, Bradford, with help from The Art
Fund and the National Heritage Memorial
Fund, 2002; p.41 NPG P7(26) Purchased
with help from Kodak Ltd, 1973; p.42 NPG
1767 Bequeathed by Henry James, 1916;
p.43 NPG 1028 Given by Sir William Blake
Richmond, 1896; p.44 (top) NTPL; p.46 NPG
2929 Bequeathed by the sitter's widow, Mrs
Florence Emily Hardy, 1938; p.47 NPG P123
Given by Alfred Jones, 1922; p.49 NPG 1603
Bequeathed by Sir Charles Wentworth Dilke,
2nd Bt, 1911; p.50 NPG 1250 Given by Queen
Victoria, 1900; p.51 NPG 237 Given by Queen
Victoria, 1867; p.52 NPG 6202 Purchased
with help from the National Heritage
Memorial Fund and The Art Fund, 1993;
p.53 NPG 6856 Purchased with help from
the National Lottery through the Heritage
Lottery Fund, and Gallery supporters, 2008;
p.54 (top) NTPL/Derrick E. Witty; p.57 NPG
5991 Given by The Art Fund, 1965; NPG 1782
Given by Pandeli Ralli, 1916; p.58 NPG 4837
Bequeathed by Sir Frank Swettenham, 1971;
(right) NTPL/John Hammond; p.59 NPG
1746 Bequeathed by Octavia Hill, 1915; p.60
©NTPL/John Miller; p.61 (both) ©NTPL/
Matthew Antrobus; p.62 (top) ©NTPL/
Simon Fraser, (bottom) ©NTPL/Andrew
Butler; p.63 (bottom) AJW Photography,
Bodelwyddan Castle Trust.

Contents

Introduction

The Victorian and Edwardian eras, from the accession of
Queen Victoria in 1837 until the death of her son, Edward VII,
in 1910, saw Britain become the world's leading industrial and
commercial power. By the end of the period changes in politics,
science and society had begun to create a view of the world that
we would recognise today. The portraits in this book record those
who were among the makers of these changes – people such as
Charles Darwin (p.27), whose theory of evolution challenged
conventional religious views of man's place in nature; William
Morris (p.15), whose ideas on art and society had a profound and
lasting influence; and Virginia Woolf (p.44), who through her
writings explored the potential of womanhood.

The nature of portraiture itself was also shaped by
technological, commercial and social developments during the
period. Photography, pioneered by William Henry Fox Talbot
(p.22), among others, gave rise to a whole new means of making
portraits, while towards the end of the period, the portrait
painters rejected many of the conventions of earlier times.
A burgeoning art trade serving a new class of consumers and the
wide dissemination of engravings also affected the way portraits
were produced and gave wealth and high social status to some
of those who painted them.

Commissioned or non-commissioned portraits?

Two powerfully evocative portraits of women, Adelaide, Countess
Brownlow (right) by Frederic Leighton and Jane Elizabeth
('Jeanie') Hughes, Mrs Nassau Senior (opposite) by George
Frederic Watts, exemplify different reasons for a portrait's
creation. Like many portraits of previous ages, that of Countess
Brownlow was commissioned (in this case by her husband),
and with a specific location in mind – the staircase hall at their
home, Belton House, Lincolnshire. The portrait's scale and
monumentality owe much to its intended location. Commissions
remained the principal reason for portraits to be made during the
Victorian and Edwardian eras, but, as with Watts' portrait of
Mrs Nassau Senior, there were other motives. In this instance,

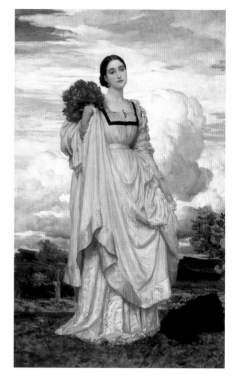

Lady Adelaide Chetwynd-Talbot,
Countess Brownlow (1844–1917)
Frederic Leighton (1830–96)
Oil on canvas, c.1879
2440 x 1660mm
Belton House, Lincolnshire

Watts painted the portrait as a gift of friendship to his sitter. Complex in its themes, and sharing stylistic affinities with works by artists of the Pre-Raphaelite movement (see p.10), the painting demonstrates Watts' desire to explore the artistic, as opposed to purely representational, aspects of portraiture.

Watts also produced a series of non-commissioned portraits for his own distinctive purposes that now forms an important part of the National Portrait Gallery's collection housed at Bodelwyddan Castle, North Wales (see p.63). This was the 'Hall of Fame' series that Watts worked on from about 1850 until the end of his long career, which consists of likenesses of his most eminent contemporaries, conceived as a record of his own times to be passed to posterity. His portrait of William Morris (p.15) is characteristic of the series and shows how Watts developed a common format in order to focus the viewer's attention on the head and face of the sitter. Like most of the series, it is confined to the sitter's head and shoulders, and there is little indication of background or dress. For his series Watts selected sitters who were noted for their intellect or vision, and by representing them in this way sought a profundity of characterisation befitting his notion of their historical importance. 'What I try for,' he wrote, 'is the half-unconscious insistence on the nobilities of the subject.' As such, these works were born out of the Victorian view that portraits could reveal an individual's inner character, a conviction promoted by the historian Thomas Carlyle, and one that underpinned the foundation of the National Portrait Gallery in 1856.

Group portraits and engravings

While many Victorian portraits strive to invest their subjects with a sense of posterity, another sort, the large group portrait, records the key historical events of the period. Paintings such as Jerry Barrett's *The Mission of Mercy: Florence Nightingale Receiving the Wounded at Scutari* (p.52) continue a tradition in British painting that blurs conventional distinctions between portraiture and history – or 'subject' – painting. In such works we are shown contemporary heroes at the moment of their greatest triumph, performing the acts for which they will be remembered. Yet, if these paintings also seem to look towards posterity, we should not ignore what must have been, for those who first saw them, a very strong sense of their contemporaneity. They are paintings produced for a public that, with the rise of the popular illustrated

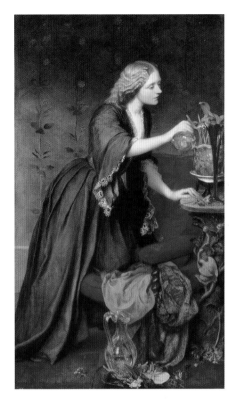

Jane Elizabeth ('Jeanie') Hughes, Mrs Nassau Senior (1828–77)
George Frederic Watts (1817–1904)
Oil on canvas, 1857–8
1765 x 1029mm
Wightwick Manor, West Midlands

press, had become used to seeing depictions of topical events. These images were, to some extent, the product of this culture, and, through being engraved, they fed back into the marketplace. Indeed, the sale of engravings was the prime motivation for their making, and nationwide tours of paintings were undertaken in order to promote the prints. Again, this shows the way in which the changing circumstances of the Victorian art market meant that not all portraits were commissioned works in the traditional sense. A work like Barrett's was made precisely with the profits from engraving in mind. The journey to Scutari was subsidised by the art firm Agnew's, who then bought the resulting painting, including its copyright, and published the engraving of it in April 1858. Likewise, Thomas Jones Barker's *The Secret of England's Greatness* (p.53), with its evangelising and imperialist subject matter, went on an extensive nationwide tour and was made into a popular engraving.

Developments in popular journalism and methods of reproduction during the Victorian period made portraiture more widely available than ever before. One newspaper commented on the engraving of the companion painting to Barrett's *Mission of Mercy* that it will be 'a memorial to be hung up by many an English hearth.' Individual portraits were also tied to the print trade. A portrait of the great statesman William Ewart Gladstone by John Everett Millais (p.54), one of the most successful portraitists of the age, was done on speculation. Agnew's bought it from the artist for £1,000, including copyright, and sold it as a print priced at between one and six guineas, depending on the proof state. This was the upper end of the market. The invention of photography in the period eventually led to the mass dissemination of portraits, whether as original photographs, such as the inexpensive cartes-de-visite of the 1860s, for example that of Queen Victoria and Prince Albert (right), or through the countless cheap engravings made from photographs.

The photographic portrait

Photography is the crucial development that sets Victorian portraiture apart from that which came before. The effect it had on the aesthetics and practice of the painted portrait is harder to assert. Its invention and gradual development as a commercially viable medium for portraiture certainly led to the decline of one type of portraiture: the portrait miniature. But limitations in its scale, and the sensitivity to light of early photographic processes,

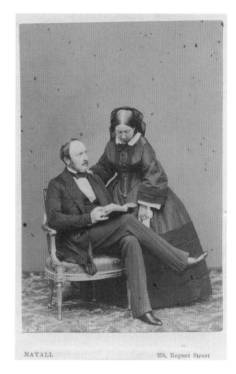

Prince Albert (1819–61)
and Queen Victoria (1819–1901)
J.J.E. Mayall (1813–1901)
Albumen carte-de-visite, May 1860
87 x 58mm
NPG Ax47001

did not make it a real challenge to oil painting. Instead, there seems to have been a certain amount of interdependence between the two forms of portraiture. While artists such as Watts and Millais used photographs as aids in getting a likeness, it might be said that the greatest early photographers, such as Julia Margaret Cameron, aspired to, and often achieved, the sort of effects more commonly associated with the painted portrait. There is a similarity in tone and expression, for instance, between Cameron's portraits (p.47) and those by her friend, Watts (pp.5, 14–15, 33).

To the modern viewer, Victorian portrait photographs can have a striking immediacy. Robert Howlett's depiction of Isambard Kingdom Brunel (p.23), which shows the great engineer standing before the massive chains of his ship the *Great Eastern*, impresses with its feeling of modernity, while a very early photograph of his father, Marc Isambard Brunel (right), is remarkable as an image of a man who we chiefly associate with the pre-photographic age. It was certainly taken within a decade of the invention of the daguerreotype process, of which it is an example. By the end of the century, a photograph such as Frederick H. Evans's portrait of Aubrey Beardsley (p.8) demonstrates the level of perfection, both technical and aesthetic, that portrait photography had achieved.

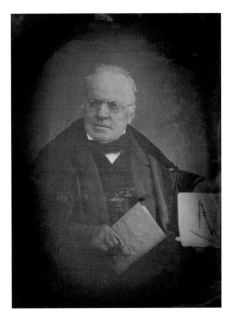

Sir Marc Isambard Brunel (1769–1849)
Unknown photographer
Daguerreotype, *c.*1845
95 x 70mm
NPG P578

Friendship portraits and the avant-garde

Like Watts' portrait of Mrs Nassau Senior, Evans's Beardsley is a permanent record of friendship between sitter and portraitist. Within this guide there are other portraits that register such friendships: Daniel Maclise's painting of the young Charles Dickens (p.36), for example, or Millais' of Wilkie Collins (p.35). Indeed, portraits are often at their most interesting when they disclose relationships or when the circumstances of their making evoke something of their era. The fact that we know Jules Bastien-Lepage's sketch of Henry Irving (p.32) was conceived at a supper party at the Lyceum Theatre, with both Ellen Terry and Sarah Bernhardt present, makes it far more than a mere likeness of the actor. In the same way, William Blake Richmond's unfinished portrait of Robert Louis Stevenson (p.43) takes us back to the hot, thundery afternoon of 10 August 1886, when Stevenson visited the artist's studio in Hammersmith and sat talking and smoking with him and other notable guests while Richmond painted.

Bastien-Lepage's portrait of Irving was acquired by the National Portrait Gallery in 1910 – right at the end of the period covered by this book – and was welcomed by the Gallery's Director of that time, Charles Holmes, as a breath of fresh air for its informality. It also exemplifies the type of French naturalism that, together with later movements in French avant-garde painting, such as Impressionism, profoundly influenced aspects of portraiture in Britain. Something of the immediacy of French painting comes through in the portraits by John Singer Sargent, who studied in Paris (pp.42, 58–9), while William Orpen's powerful portrait of Augustus John (p.18) links two progressive artists of the younger generation. There is a synergy between the informality of this type of portraiture and the beliefs and lifestyles of those it was often employed to depict. Roger Fry's portrait of Edward Carpenter (opposite) is by an artist and critic who, more than anyone, promoted the cause of modern art in this country in the closing years of the Edwardian era. It also shows a man who in his political beliefs and open homosexuality dissented from many of the orthodoxies of the Victorians.

Peter Funnell

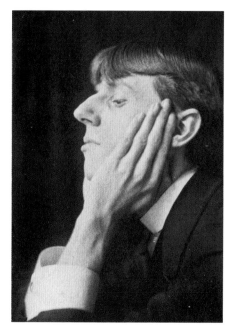

Aubrey Beardsley (1872–98)
Frederick H. Evans (1852–1943)
Platinum print, 1893
130 x 98mm
NPG P114

Edward Carpenter (1844–1929)
Roger Fry (1866–1934)
Oil on canvas, 1894
749 x 438mm
NPG 2447

Art

The nineteenth and early twentieth centuries saw a dramatic expansion in the production and consumption of visual art. Artistic patronage was no longer the preserve of royalty and nobility, as wealthy industrialists and financiers began to commission and collect. The increase in the number of middle-class consumers also enabled new forms of participation and publicity to develop.

The summer exhibitions at the Royal Academy of Arts in London became must-see events and provided a forum for leading artists, such as George Frederic Watts, Frederic Leighton and John Everett Millais, to display their latest works. Famous images were made widely available in the form of engravings, while the original works they were based on travelled the country on promotional tours. From the 1860s paintings could also be reproduced as high-quality illustrations in books and magazines.

As well as portraits and landscapes, the most popular pictures told a story for viewers to 'read', with subjects taken from literature, religion and history. Over the period, artistic styles evolved in an increasingly modern manner. The tradition of the Old Masters was rejected in 1849 by the Pre-Raphaelite Brotherhood, a group of young artists led by Millais, William Holman Hunt and Dante Gabriel Rossetti. The Pre-Raphaelites, who despised what they considered to be the fusty approach of established painters, favoured realistic depictions and bright colours.

This style then gave way to the softer forms of the Aesthetic movement, headed by Edward Burne-Jones and showcased at the Grosvenor Gallery in London, which rejected the moral value of art in favour of 'art for art's sake'. The Arts and Crafts movement, led by William Morris, encouraged a return to traditional methods of production in response to industrial manufacture.

From the 1870s British art was influenced by international movements such as Impressionism, Symbolism, Japonisme, and, by 1910, Post-Impressionism. The two main art schools, the Royal Academy and the Slade School, based their training on drawing the human figure from life. At the start of the period men dominated the art scene as producers and buyers, while women remained subjects and sitters. However, as the century progressed, more women became known as artists and critics, a development supported by better art education for women during the Edwardian years.

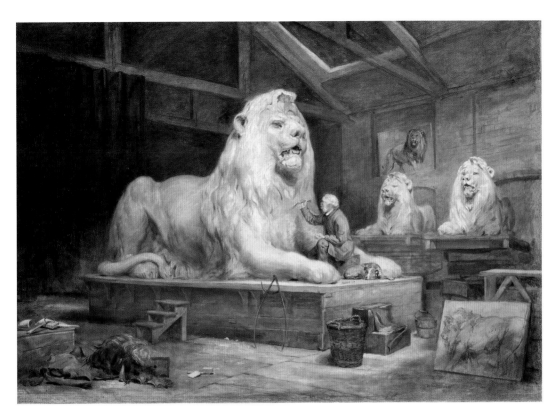

Sir Edwin Landseer
John Ballantyne (1815–97)
Oil on canvas, c.1865
800 x 1130mm
NPG 835

Edwin Landseer (1802–73) is shown in the studio of
Baron Marochetti modelling one of the lions for the
base of Nelson's Column in Trafalgar Square. This
project occupied him on and off between 1858 and 1866
and contributed to the ill health that clouded the last
decade of his life. Known partly for his amusing and
sentimental paintings featuring his pet dogs, Landseer
is here attended by a collie. The dog is thought to be
Lassie, his constant companion in the studio at this
time. The portrait is one of a series by Ballantyne of
artists in their studios, which he exhibited as a set in
November 1865.

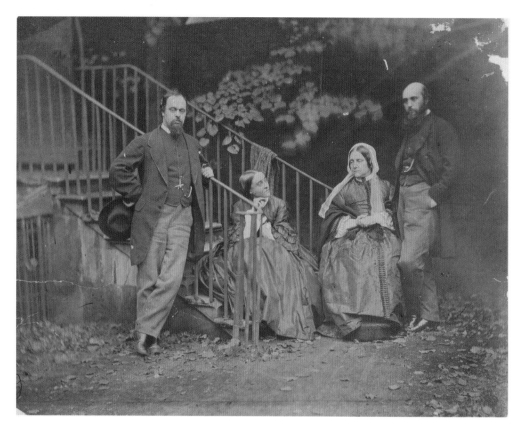

The Rossetti Family
Lewis Carroll (1832–98)
Albumen print, 1863
175 x 222mm
NPG P56

This photograph is one of a series of the Rossetti family taken by Lewis Carroll on 7 October 1863 in the garden of the house in Cheyne Walk, London, that belonged to Dante Gabriel Rossetti (1828–82). Although best remembered as an artist, Dante Gabriel (standing on the left of the group) was also a significant, if controversial, poet. Seated next to him is his sister, Christina (1830–94), one of the greatest poets of the Victorian period, while standing on the right, beside their mother Frances (1800–86), is William Michael Rossetti (1829–1919), a distinguished art critic and historian.

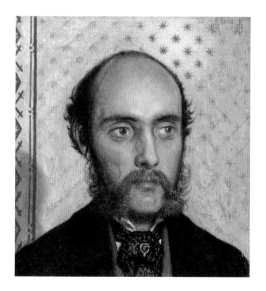

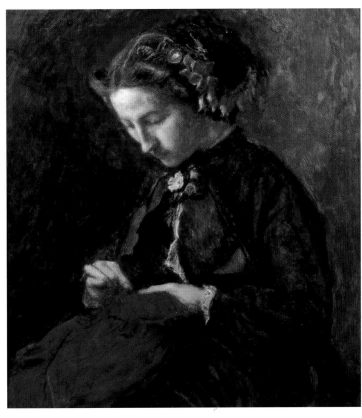

Euphemia Chalmers ('Effie') Gray, Mrs John Ruskin, later Lady Millais (*The Foxglove*)
Sir John Everett Millais (1829–96)
Oil on panel, 1853
230 x 210mm
Wightwick Manor, West Midlands

This portrait of Effie Ruskin (1828–98) was painted while she and her first husband were holidaying with John Ruskin's protégé, John Everett Millais, and his brother William, at Callander in July 1853. It was while on holiday that Millais and Effie fell in love. Her marriage to Ruskin had never been consummated and the following year the union was annulled amid great public scandal. Effie and Millais were married in 1855 and went on to have eight children.

William Michael Rossetti by Gaslight
Ford Madox Brown (1821–93)
Oil on panel, 1856
170 x 165mm
Wightwick Manor, West Midlands

William Michael Rossetti (1829–1919), Dante Gabriel's brother, was a civil servant from 1845 and was a founder member of the Pre-Raphaelite Brotherhood. He had little talent for painting, but acted as secretary to the Brotherhood and editor of its short-lived journal, *The Germ*. In later years he established himself as a leading art critic and acted as a stabilising influence on his brother's increasingly erratic lifestyle.

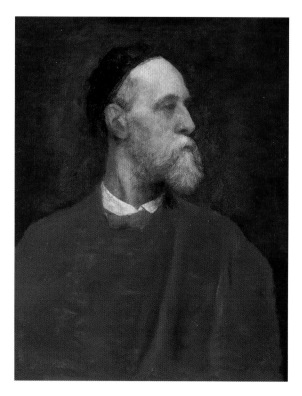

George Frederic Watts
Self-portrait
Oil on canvas, *c.*1879
635 x 508mm
NPG 1406

By the end of his life George Frederic Watts (1817–1904) was considered to be the greatest British artist of his age. His large, allegorical works on universal themes appealed greatly to the Victorians. As a portraitist Watts had an enormous output, producing over 300 portraits in oils and countless drawings between the 1830s and his death in 1904. Today he is best known for his 'Hall of Fame' series of paintings of distinguished men of his time, produced entirely at his own expense. As one of the celebrities of Victorian England, he counted Tennyson, Ruskin, the Pre-Raphaelite artists and the pioneer photographer Julia Margaret Cameron among his friends.

William Morris
George Frederic Watts (1817–1904)
Oil on canvas, 1870
648 x 521mm
NPG 1078

William Morris (1834–96) was one of the most important and inventive artistic figures of the Victorian period, and his name has become synonymous with the Arts and Crafts movement. His home, Red House in Bexleyheath (now owned by the National Trust), was a social centre for the Pre-Raphaelite circle and his firm, Morris & Co., which designed and manufactured furniture, fabrics, wallpapers and stained glass, espoused standards of craftsmanship that Morris traced back to the medieval period, rather than following the trend for mass production. Both his approach and his characteristically rich and colourful designs were highly influential. His wish to find dignity in work led to political action, and in 1884 he founded the Socialist League. His influence, in art, design, printing and manufacture, remains extremely important.

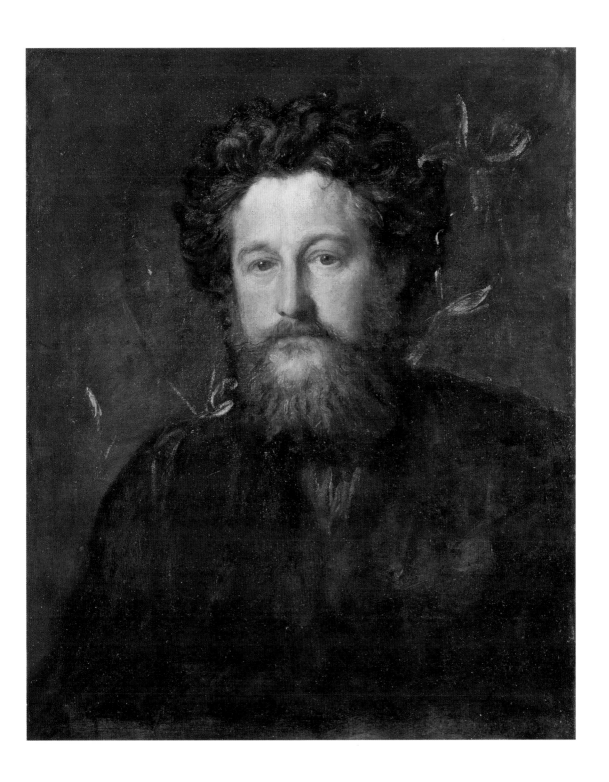

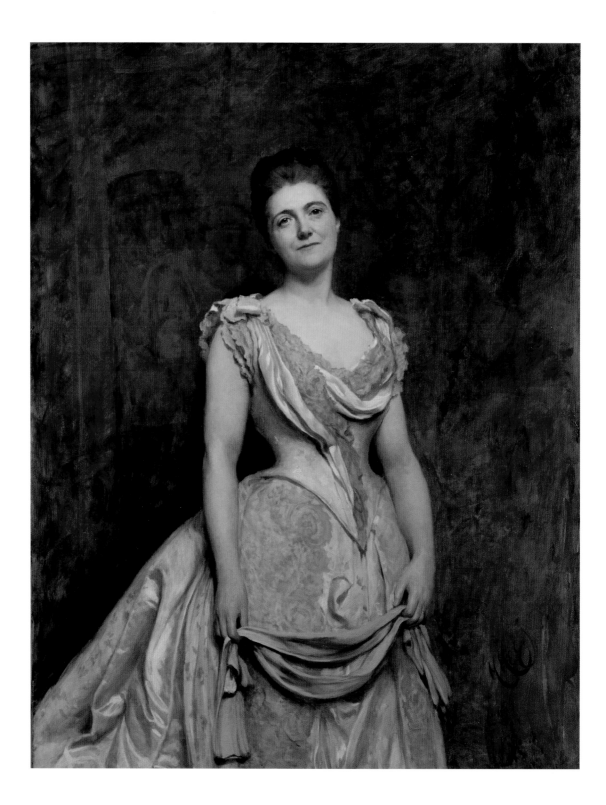

Emilia Francis, Lady Dilke
Sir Hubert von Herkomer (1849–1914)
Oil on canvas, 1887
1397 x 1092mm
NPG 5288

Emilia Francis Dilke (1840–1904) began writing
reviews and articles on art in the mid-1860s, and was
the salaried art editor of *The Academy* from 1873 to
1888. Her first book, *The Renaissance of Art in France*
(1879), was followed by a major study of Claude
Lorrain (1884). She was a close friend of and frequent
visitor to the home of Pauline Trevelyan at Wallington
in Northumberland (now owned by the National
Trust). On the death of her first husband she married
the Liberal politician Sir Charles Dilke. Also active in
support of working women, Lady Dilke was president
of the Women's Trade Union League from 1886 until
her death.

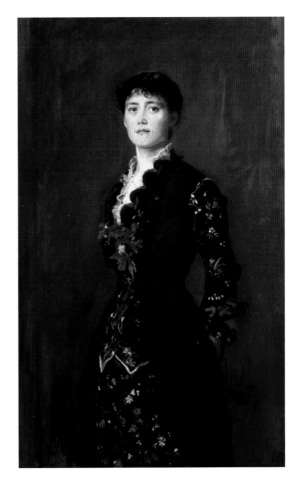

Louise Jopling
Sir John Everett Millais (1829–96)
Oil on canvas, 1879
1245 x 760mm
NPG 6612

Louise Jopling (1843–1933) studied art in Paris in the
mid-1860s and supported her family through painting
and illustration after the collapse of her first marriage.
In 1874 she married the watercolourist Joseph Jopling.
She exhibited portraits and subject paintings at the
Paris Salon from 1869, the Royal Academy from 1871
and the Grosvenor Gallery from its founding in 1877.
Jopling was a central figure in artistic and literary circles
of the period and a close friend of her fellow painters
Whistler and Millais, who produced this portrait of her.
She established her own art school to train women
painters in 1887 and was a supporter of the National
Union of Women's Suffrage.

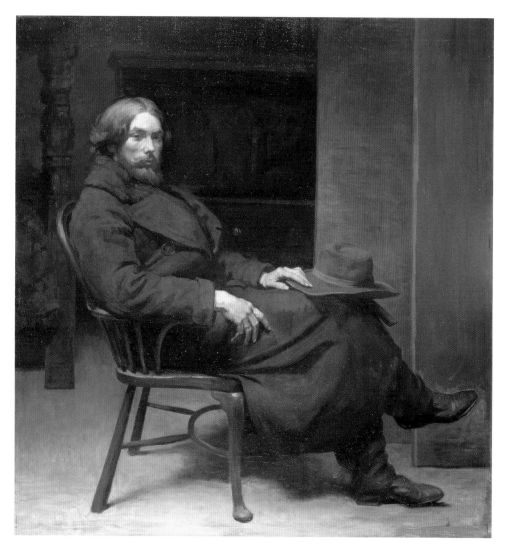

Augustus John
Sir William Orpen (1878–1931)
Oil on canvas, exhibited 1900
991 x 940mm
NPG 4252

Augustus John (1878–1961) was a leading figure of the
avant-garde in the Edwardian period. A flamboyant
personality, who cultivated a strong bohemian image for
himself, John's later work never quite fulfilled his early
promise. Orpen and John met while studying at the Slade
School of Art and became constant companions. Fifty
years later John criticised this portrait for not conveying
'the shy, dreamy and reticent character of its model'. It is
in fact one of Orpen's finest early portraits, depicting a
young artist whose behaviour was often far from 'reticent'.

Lady Colin Campbell
Giovanni Boldini (1842–1931)
Oil on canvas, c.1897
1843 x 1202mm
NPG 1630

Gertrude Blood (1857–1911) married Lord Colin Campbell, younger son of the Duke of Argyll, in 1881, but separated from him five years later after a scandalous case in which he alleged her adultery with four other men. She worked as an art critic for the *World* and the *Ladies' Field*, and was admired for her athletic prowess in fencing, swimming and riding. Her published works include *A Book of the Running Brook: and of Still Waters* (1886), articles on English freshwater fish, and *Etiquette of Good Society* (1893). The Italian society painter Boldini imparted a special glamour to this alluring sitter, revelling in her provocative expression and voluminous black dress, and treating the rules of anatomy with magnificent contempt. Although much admired by some, the painter Walter Sickert later referred with scorn to the 'Wriggle-&-Chiffon School of Boldini'.

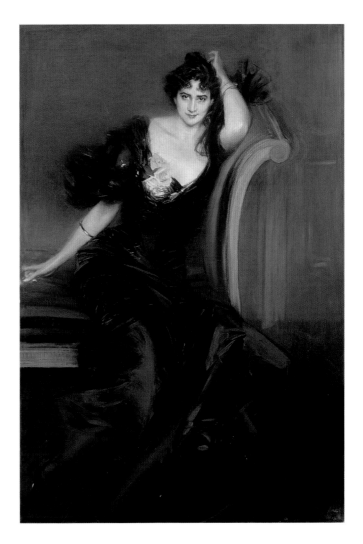

Science and industry

Scientific developments and technological innovations transformed the British way of life during the nineteenth and early twentieth centuries. Horse-drawn transport was replaced by the steam train, bicycle and motor car; candles and oil lamps gave way to gas lights and then electricity; postal services were supplemented by the telegraph and telephone; quill pens were replaced by typewriters, and portraiture was transformed by the invention of photography. During the Victorian and Edwardian eras Britain became the world's leading industrial power, and the inventions of the period continue to shape the way we live today.

Some of the scientists, engineers and industrialists who brought about these changes became rich and famous. While others remained relatively unknown, their achievements profoundly influenced society through science teaching and popular accounts of discoveries and inventions. The majority of the personalities in this section are represented not by oil paintings but by photographs, reflecting the fact that it was often the scientific discoveries and technological inventions that became well known, rather than the individuals responsible for them.

Advances in science and medicine included the development of anaesthetics in the 1840s, the understanding of the germ theory of disease in the 1870s, the demonstration of radio waves in 1887 and the invention of cinematography in the 1890s. Dynamite was invented in 1867, and from the 1870s automatic artillery weapons were manufactured. The tracked military tank was first described in a story by H.G. Wells in 1903, and the first aeroplanes flew in the same decade.

The discoveries of geologists and astronomers and Charles Darwin's theory of evolution fundamentally altered the accepted understanding of our place in the natural world. For many, natural forces replaced divine will as the explanation for life and the universe, and convictions held for centuries were challenged. The scientific method of observation, experiment and proof became the standard form of inquiry, while knowledge and practical applications spread worldwide, as people and ideas traversed the globe.

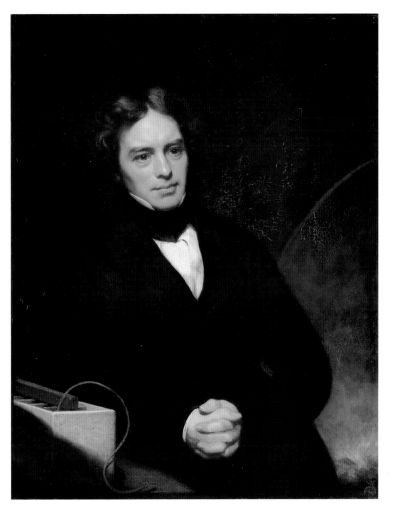

Michael Faraday
Thomas Phillips (1770–1845)
Oil on canvas, 1841–2
908 x 711mm
NPG 269

Born the son of a blacksmith, and largely self-taught, Michael Faraday (1791–1867) became one of the greatest of all scientists. He received his scientific education working as assistant to Sir Humphry Davy at the Royal Institution from 1813. It was there, on 29 August 1831, that he made his greatest discovery: electromagnetic induction. This breakthrough led to a series of experiments carried out over the following ten weeks that are now acknowledged as the basis of modern electrical technology. This portrait shows him with two essential pieces of laboratory equipment: on the left is a Cruikshank battery of the sort he used in his electrical experiments, while the flames on the right indicate a furnace, which was necessary for a range of laboratory work at this time.

William Henry Fox Talbot
John Moffat (1819–1894)
Photograph, 1864
Dimensions vary
Fox Talbot Museum, Lacock, Wiltshire

This studio portrait of William Henry Fox Talbot
(1800–77) holding the lens to a camera was taken
by John Moffat of Edinburgh in 1864. Fox Talbot had
begun photographic experimentation in 1834 and is
known as the father of photography for having invented
the calotype process, which involved the production of
negatives from which positive prints could be made.
Lacock Abbey, his family home, is known as the home
of photography and features in the oldest extant
negative, an image of the oriel window in the South
Gallery made in 1835 (below).

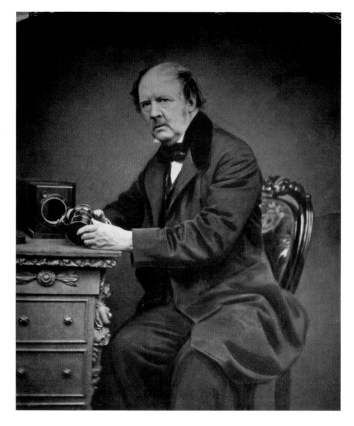

Oriel window, South Gallery,
Lacock Abbey
William Henry Fox Talbot (1800–77)
Print from the first negative of the
window in 1835
Original negative 36 x 28mm
Lacock Abbey, Wiltshire

Visitors to Lacock, which is owned by
the National Trust, can take their own
versions of this remarkable photograph.

Isambard Kingdom Brunel
Robert Howlett (1830–58)
Albumen print, 1857
286 x 225mm
NPG P112

The son of the engineer Sir Marc Isambard Brunel
(p.7), Isambard Kingdom Brunel (1806–59) gained
early experience working on his father's Thames
Tunnel in London. He went on to design the Clifton
suspension bridge in Bristol and to build not only the
Great Western Railway, in England, but also railways
in Italy, India and Australia. He is also remembered as
a designer of ocean-going steamships, the last and the
greatest of which was the *Great Eastern*, whose massive
anchor chains provide the backdrop in this photograph.
Taken to celebrate the launch of the steamship, this
photograph demonstrates the importance of the
picture-selection process. Of several images taken by
Howlett that day, this was the only one with the power
to fix Brunel in the public's mind.

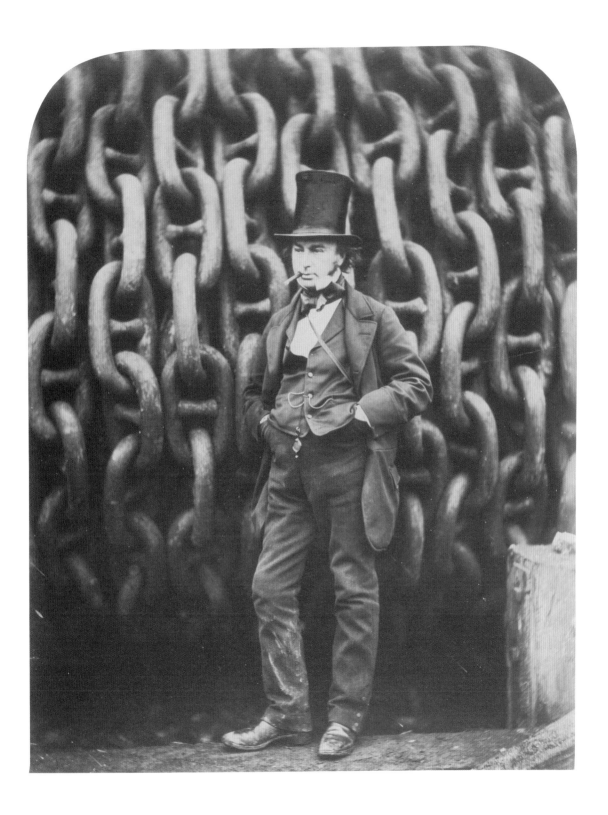

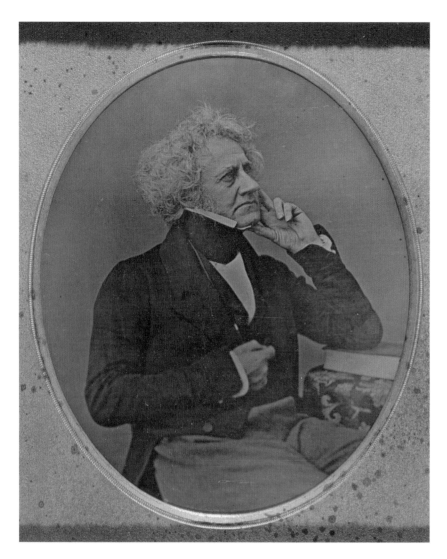

Sir John Herschel
J.J.E. Mayall (1813–1901)
Daguerreotype, *c.*1848
86 x 70mm
NPG P660

John Herschel (1792–1871) was a commanding figure
in the Victorian scientific world who made outstanding
discoveries in the fields of astronomy, mathematics,
chemistry and optics and was the inventor of many
early photographic processes. As a daguerreotype,
this is a unique image and is the earliest recorded
photograph of Herschel. This portrait links one of
photography's scientific pioneers with one of its leading
early practitioners, J.J.E. Mayall. It is of outstanding
importance in the history of photography.

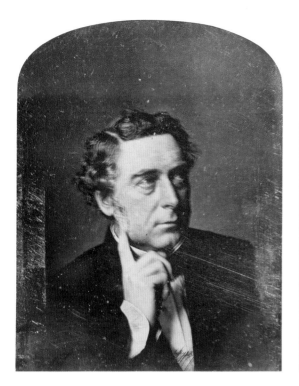

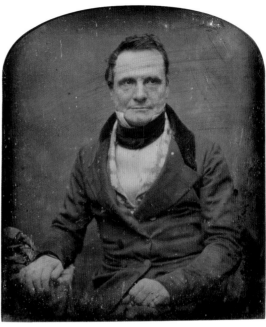

Robert Stephenson
Unknown photographer
Daguerreotype, *c.*1851
114 x 89mm
NPG P4

Son of the railway pioneer George Stephenson, Robert
Stephenson (1803–59) supervised the construction
of the famous steam engine the *Rocket* at his father's
Newcastle works. From 1838 he constructed, or advised
on the construction of, railways in Britain and abroad.
This daguerreotype may have been taken to assist
John Lucas in his group portrait *Conference of
Engineers at the Menai Straits* (*c.*1851–3), which was
commissioned by the Institute of Civil Engineers to
commemorate the building of the Britannia Bridge,
which linked Anglesey to the Welsh mainland.

Charles Babbage
Antoine Claudet (1798–1867)
Daguerreotype, *c.*1847–51
70 x 60mm
NPG P28

Even by Victorian standards, Charles Babbage (1791–1871)
was a formidable polymath. He was a mathematician,
scientist and inventor, a political economist and a
social reformer. But he is best remembered today as a
pioneer of computer technology and the inventor of the
calculating machine; the development of his Difference
Engine and, later, his Analytical Engine, dominated his
life's work. A native of Lyon, France, Claudet came to
England in 1829 and in the 1840s became a leading
practitioner of the daguerreotype. Claudet was working
with Babbage on various photographic experiments
around the time this portrait was taken.

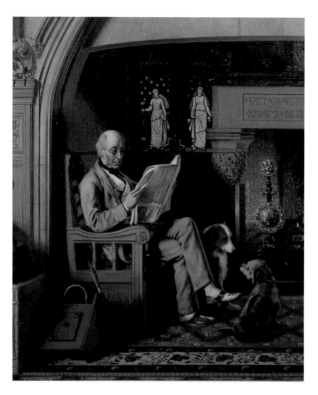

William Armstrong, Baron Armstrong
Henry Emmerson (1831–95)
Oil on canvas, 1859–87
762 x 635mm
Cragside, Northumberland

William Armstrong (1810–1900) was a noted inventor,
known for his pioneering work on hydraulics, arms
and armaments, warships, cranes, bridges, cars and
aircraft. He had been a solicitor, but a passion for
engineering led him to found Armstrong and Co. in
1847, which dominated Tyneside for generations. The
companies he founded still exist in various forms,
although rarely under the 'Armstrong' name. Here he
is shown seated with his two dogs at his feet in the
inglenook fireplace in the dining room at his house,
Cragside, Northumberland, which is now owned by the
National Trust.

Charles Darwin
John Collier (1850–1934)
Oil on canvas, 1883 (1881)
1257 x 965mm
NPG 1024

This portrait of Charles Darwin (1809–82), the great
scientist and author of *On the Origin of Species*, is a
replica by the artist of a painting undertaken for the
Linnaean Society. It shows Darwin as an old man in the
year before his death. According to Darwin's third son,
Francis, 'the portrait represents him standing facing
the observer in the loose cloak so familiar to those who
knew him and with his slouch hat in his hand. Many of
those who knew his face most intimately, think that
Mr Collier's picture is the best of the portraits and in
this judgement the sitter himself was inclined to agree.'

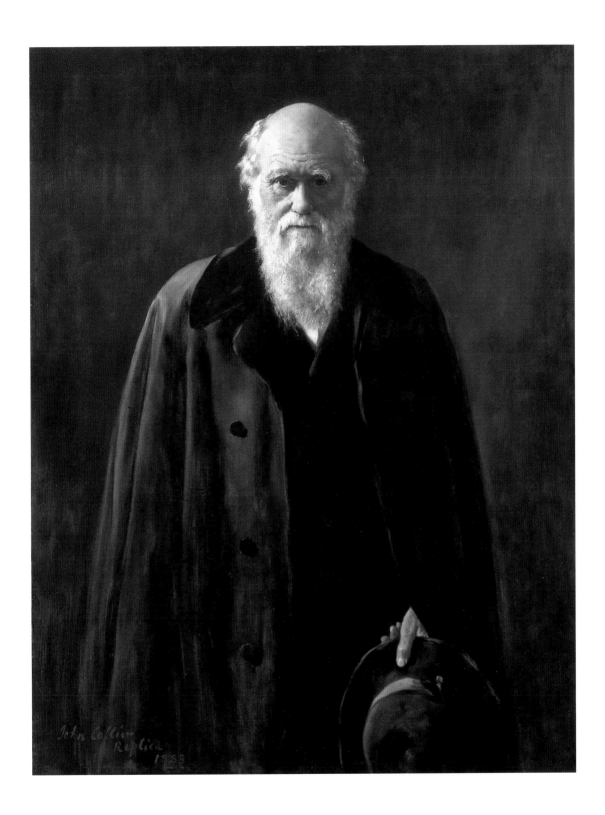

Music and theatre

As the Victorian era progressed, theatre, which had previously been considered too public and vulgar for respectable women to attend, developed into a popular entertainment patronised by everyone, from aristocrats to artisans. Actors and singers became national celebrities and their publicity pictures reached the public through cheaply available photographic reproductions. In response, artists strove to capture famous personalities in their painted portraits.

Technical innovations provided the potential for spectacular stage productions, and by the middle of the century theatregoers were presented with a wide range of options, from Shakespearian tragedy to comic operettas, with pantomime and melodrama being the most popular. The 'star system' evolved, and leading actors, such as Henry Irving, became impresarios, directing theatres and even receiving honours. Some dramatists became famous, but most remained relatively obscure until the 1890s when the 'New Drama' began to examine contemporary life with seriousness and wit; here Oscar Wilde and George Bernard Shaw led the field.

Before the invention of sound recording and cinema, people listened to live music at home, in the concert hall and in the streets, where buskers performed for pennies and new songs circulated. There was a large market for songs with piano accompaniment and for choral music for public and church performance. Although orchestral music was mainly imported (Beethoven and Brahms were among the most favoured composers), a new English music emerged towards the end of the nineteenth century, with the works of Edward Elgar being particularly acclaimed.

Musical theatre flourished in a variety of forms, from the ever-present music hall to Italian opera, popular in the 1840s, and Wagner's Ring Cycle of the 1880s. Gospel music was introduced to Britain in the 1870s by the Jubilee Choir, who sang for Queen Victoria. In the same decade Gilbert and Sullivan introduced the nation to a very English form of comic operetta that continued to attract large audiences throughout the reign of Edward VII.

Oscar Wilde
Napoleon Sarony (1821–96)
Albumen panel print, 1882
305 x 184mm
NPG P24

Irish-born playwright, wit and apostle of
the Aesthetic movement, Oscar Wilde
(1854–1900) achieved fame while still
an undergraduate at Oxford. His period
of greatest creativity – which saw the
publication of the novel *The Picture of
Dorian Gray* (1891) and a succession
of brilliant stage comedies culminating
in *The Importance of Being Earnest*
(1895) – was cut short following his
imprisonment arising from a conviction
of gross indecency. Sarony's photograph
shows him in New York in January 1882,
wearing full aesthetic garb and preparing
to proclaim his creed of art and beauty to
audiences across North America. Sarony
declared that Wilde was 'a picturesque
subject indeed'.

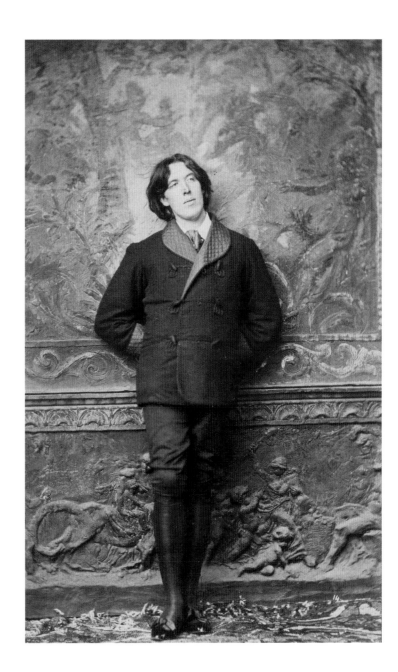

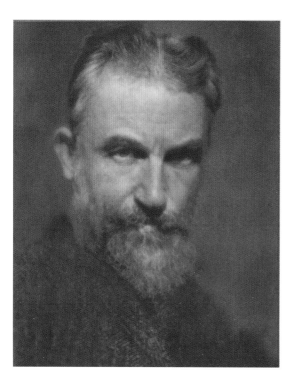

George Bernard Shaw
Alvin Langdon Coburn (1882–1966)
Photogravure, 1904
206 x 159mm
NPG Ax7768

George Bernard Shaw (1856–1950) is one of the literary giants of the modern period, whose writings span a vast spectrum of subjects and ideas and whose influence was felt in politics and society at large. Towards the end of the nineteenth century he wrote important musical and dramatic criticism, introduced the British public to the work of Ibsen, and wrote some of his best plays. Successful seasons at the Royal Court Theatre (1904–7) established Shaw's reputation, and many of his plays, including *Major Barbara* (1905) and *Pygmalion* (1914), later reached wider audiences as popular films. He was awarded the Nobel Prize for Literature in 1925. His country home, Shaw's Corner in Hertfordshire, was bequeathed to the National Trust.

Sir Edward Elgar
Edgar Thomas Holding (1870–1952)
Platinum print, *c*.1905
193 x 109mm
NPG x11905

Largely self-taught, Edward Elgar (1857–1934) came to prominence in the 1890s with high-profile commissions including the *Imperial March* for Queen Victoria's Diamond Jubilee (1897). His international breakthrough came with the orchestral *Enigma Variations* (1899), a series of musical portraits of his wife and friends. His reputation as a leading British composer was confirmed the following year with the oratorio *The Dream of Gerontius*. Elgar was knighted in 1904 and was appointed Master of the King's Musick in 1924.

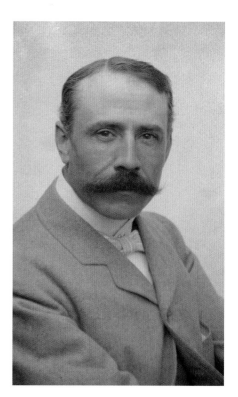

Sir William Schwenck Gilbert
Frank Holl (1845–88)
Oil on canvas, 1886
1003 x 1257mm
NPG 2911

One half of the immortal partnership of Gilbert and
Sullivan, W.S. Gilbert (1836–1911) was responsible for
some of Britain's greatest comic operettas. Gilbert
qualified as a lawyer, but abandoned the law to write
libretti for Arthur Sullivan's music. Their work included
HMS Pinafore (1878), *Iolanthe* (1882), *The Mikado* (1885)
and *The Yeoman of the Guard* (1888). The appearance of
this gentleman, with his military moustache, corduroy
jacket and hunting crop, is therefore somewhat
unexpected. In this portrait Gilbert, who was obliged
to ride for two hours every day in order to alleviate his
gout, wears riding dress.

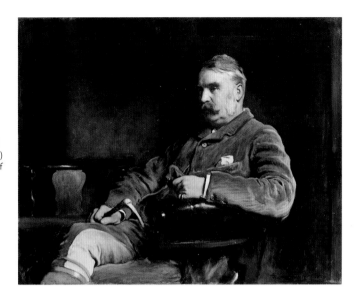

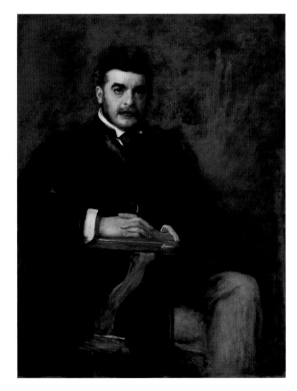

Sir Arthur Sullivan
Sir John Everett Millais (1829–96)
Oil on canvas, 1888
1156 x 870mm
NPG 1325

Arthur Sullivan (1842–1900) achieved early success as
a composer of serious music. In 1866 he wrote *Cox and
Box*, a comic operetta, and in 1872 first collaborated
with W.S. Gilbert on *Thespis*. With Gilbert as librettist,
Sullivan composed a series of triumphantly successful
comic operettas, performed after 1881 at the Savoy
Theatre in London, which was built for them by Richard
D'Oyly Carte. Sullivan also composed numerous songs,
including 'The Lost Chord' (1877), orchestral and sacred
pieces, and one grand opera, *Ivanhoe* (1891).

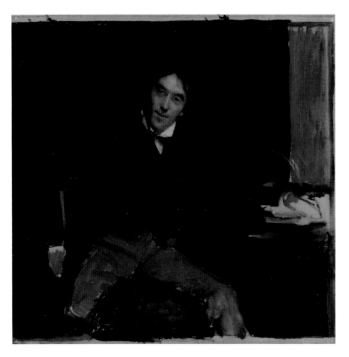

Sir Henry Irving
Jules Bastien-Lepage (1848–84)
Oil on canvas, 1880
432 x 457mm
NPG 1560

Sir Henry Irving
Onslow Ford (1852–1901)
Bronze bust, 1883
457mm high
NPG 5689

Henry Irving (1838–1905) dominated the London
stage for the last thirty years of Victoria's reign. He
established his reputation as a tragic actor with his
Hamlet at the Lyceum Theatre in 1874. His style was
individual and controversial, but its power and intensity
held audiences spellbound. A great manager as well
as an actor, Irving organised several American and
Canadian tours, received many honours and was the
first actor to be knighted. This portrait was conceived
at a supper party at the Lyceum Theatre on 3 July
1880, when Irving and Ellen Terry entertained the artist
Bastien-Lepage and the actress Sarah Bernhardt. It was
abandoned after only one or two sittings, presumably
because Irving intensely disliked the informal depiction
of him. A more heroic image of Irving is Onslow Ford's
bust, a version of his life-size marble showing him in
the role of Hamlet. Other portraits and memorabilia
relating to Irving can be found at Grey's Court in
Oxfordshire, owned by the National Trust.

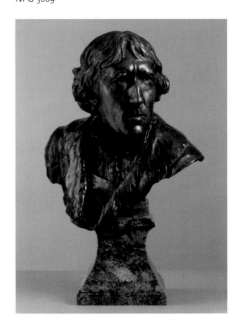

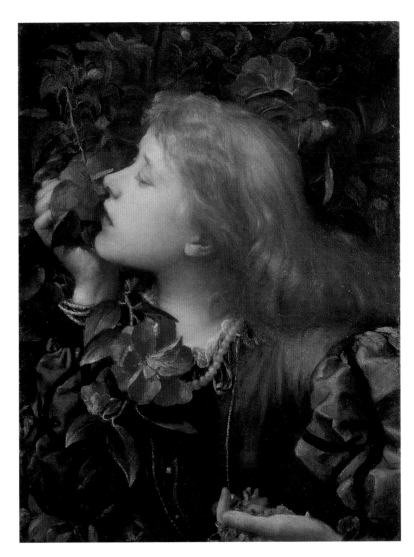

Dame Ellen Terry (*Choosing*)
George Frederic Watts (1817–1904)
Oil on strawboard, *c*.1864
472 x 354mm
NPG 5048

Ellen Terry (1847–1928) first appeared
on stage at the age of nine in 1856.
Regarded as the greatest English actress
of the period, she began performing with
Henry Irving in 1867, and played many
leading roles in Irving's productions
between 1878 and 1896. Known as
Choosing, this delicately sensuous
portrait shows the seventeen-year-old
sitter choosing between the camellias,
symbolising worldly vanities, by which
she is surrounded, and in her left hand
a small bunch of violets, symbolising
innocence and simplicity. She married
Watts, thirty years her senior, in 1864,
but they separated the following year.
Smallhythe, Kent, Terry's home from
1899 until her death, holds a fascinating
collection of her theatrical costumes and
is now owned by the National Trust.

Literature

Cheaper methods of printing made books more accessible in the nineteenth century and reading aloud at home was a popular pastime. Writers became celebrities who helped to define the age. Readers sought portraits of their favourite authors, and artists competed to paint them.

In 1850 Alfred Lord Tennyson became Poet Laureate, and the sonorous rhythms and grand themes of his work resonated with the times. His predecessor, William Wordsworth, and other Romantic poets, such as Samuel Taylor Coleridge and Robert Southey, were associated with the landscape of the Lake District. The homes of later writers and novelists, such as that of the Brontë sisters, also became sites of literary pilgrimage.

Above all, the Victorian years proved to be the age of the novel, with so called 'three-decker' sagas offering a historical romance or a vivid drama of contemporary society. The whole nation avidly followed the latest instalments from famous authors, such as Charles Dickens, Anthony Trollope, Wilkie Collins and Thomas Hardy, whose works were serialised in magazines. Women writers, such as Elizabeth Barrett Browning, Christina Rossetti, and, later, Virginia Woolf, achieved similar levels of fame to their male counterparts, although the Brontë sisters and Marian Evans (George Eliot) wrote under male pseudonyms.

While the Bible remained primary reading-matter for all classes, other religious books declined in popularity. New genres, including detective stories, psychological thrillers and science fiction, captivated readers. Writers such as Henry James developed novels of introspective analysis, and in the 1900s innovative literary styles heralded the rise of Modernism. Children's literature also flourished, as adventure stories, fantasy novels and fairy tales proliferated.

Rising literacy levels created a wide audience for works of instruction and encouragement, such as Samuel Smiles's *Self-Help*. History, biography and polemic grew into major genres, interpreting past and present in terms of Britain's global role and shaping national identity. Thomas Carlyle's celebration of exceptional individuals, or 'Great Men' as he referred to them, was widely influential in, to take two examples, the founding of the National Portrait Gallery and the publication of the monumental *Dictionary of National Biography*. Towards the end of the era, critical and alternative – some would say 'decadent' – views challenged this heroic mode.

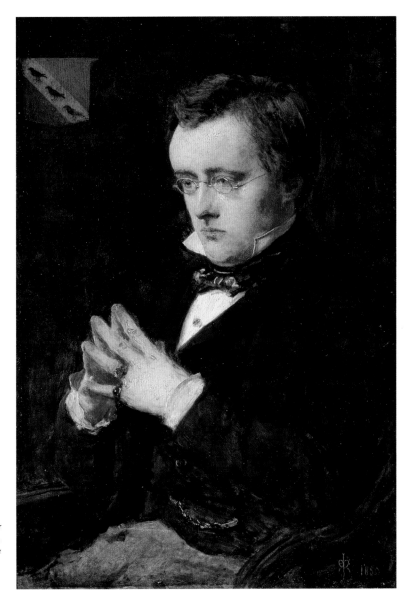

Wilkie Collins
Sir John Everett Millais (1829–96)
Oil on panel, 1850
267 x 178mm
NPG 967

The novelist Wilkie Collins (1824–89)
began his career articled to a firm
of tea merchants and subsequently
qualified as a lawyer. His literary career
developed through the friendship and
encouragement of Charles Dickens,
and Collins became a regular contributor
to Dickens's magazine *Household Words*.
As well as collaborating with Dickens, he
wrote several popular novels, including
The Woman in White (1860) and *The
Moonstone* (1868).

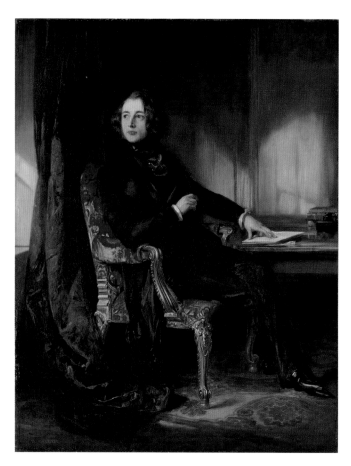

Charles Dickens
Daniel Maclise (1806–70)
Oil on canvas, 1839
914 x 714mm
NPG 1172

Charles Dickens (1812–70) was the greatest novelist of
his age and a highly prolific writer. He established his
name with *The Pickwick Papers* in 1836, and at the time
of this portrait had just published *Nicholas Nickleby*.
The Irish artist Daniel Maclise was a close friend of the
novelist and painted him on more than one occasion,
as well as making portraits of his wife and children.
Dickens recorded in a letter of 28 June 1839 that
'Maclise has made another face of me, which all people
say is astonishing.'

**The Brontë sisters: Anne (1820–49), Emily (1818–48)
and Charlotte (1816–55)**
Branwell Brontë (1817–48)
Oil on canvas, *c*.1834
902 x 746mm
NPG 1725

This is the only surviving group portrait of the three
famous novelist sisters, and was thought to have
been lost until it was discovered, folded up on top of
a cupboard, by the second wife of Charlotte Brontë's
husband, the Reverend A.B. Nicholls, in 1914. In the
centre of the group a male figure, previously concealed
by a painted pillar, can now be discerned; it is almost
certainly a self-portrait of the artist, their brother,
Branwell Brontë.

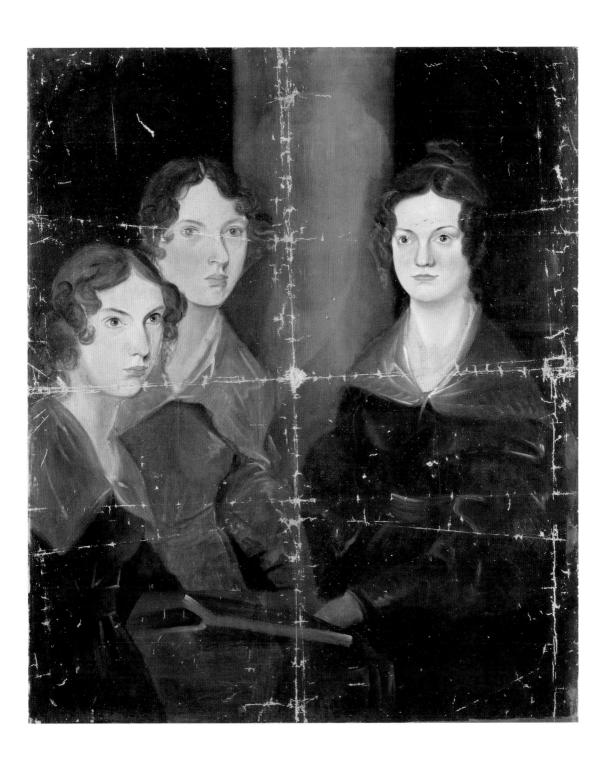

Robert Browning
Michele Gordigiani (1830–1909)
Oil on canvas, 1858
724 x 587mm
NPG 1898

Elizabeth Barrett Browning
Michele Gordigiani (1830–1909)
Oil on canvas, 1858–9
737 x 584mm
NPG 1899

Robert Browning (1812–89) is regarded as one of the greatest Victorian poets. This portrait of him was commissioned by an American admirer, Sophia Eckley, when Browning and his wife, Elizabeth Barrett Browning, were living in Florence. Eckley was determined that it would be the best available likeness of him and wrote on the stretcher that Browning described it as an 'Incomparable Portrait by far the best ever taken'. It is certainly suggestive of his intense and cerebral character; but according to William Michael Rossetti, writing after Browning's death: 'The face in this portrait is certainly a highly intellectual one; but I think it is treated with too much morbidezza [softness], so as to lack some of that extreme keenness, which characterised Browning.'

Elizabeth Barrett Browning (1806–61) was a poet like her husband, and this portrait was painted as a companion piece to his. According to a label on the back of the frame, it was done 'expressly for Sophia May Eckley and pronounced by Robert Browning to be the best portrait ever taken of the Poetess.' But at the time, Robert Browning was not convinced that it was a good likeness, writing to Eckley: 'The portrait is not perfect certainly; the nose seems over long and there are some other errors in the face; also, the whole figure gives the idea of a larger woman than Ba.' It shows Elizabeth Barrett Browning with dark hair and looking intense, and it is perhaps not surprising to learn that Eckley had introduced her to spiritualism around this time.

Isabella Beeton
Maull & Polyblank (active 1854–65)
Hand-tinted albumen print, 1857
184 x 149mm
NPG P3

Isabella Beeton (1836–65) was the author of *Mrs Beeton's Book of Household Management*. Published in 1861, the book was an essential guide to running a Victorian household. It included advice on many things, including fashion, childcare, science and a large number of recipes. Although most people think of Mrs Beeton as a source of culinary inspiration, she meant much more than this to the Victorians. The book was the embodiment of the Victorian ideology of a woman's place being in the home.

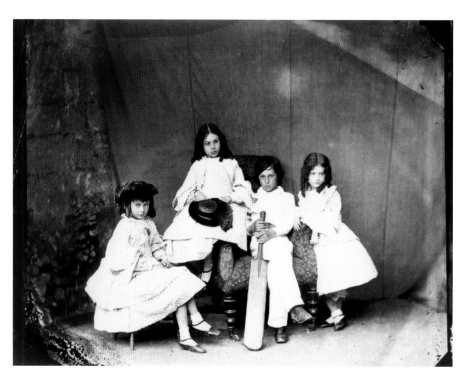

Alice, Ina, Harry and Edith Liddell
Lewis Carroll (1832–98)
Albumen print, 1860
145 x 188mm (uneven)
NPG P991(7)

Lewis Carroll, who took this photograph in the spring
of 1860, became friends with the Liddell family while
he was a colleague of their father in Oxford. Carroll
regularly entertained the children with fantastic
stories, one of which was to become *Alice's Adventures
in Wonderland* (1865), his most famous book. Alice
(1852–1934), shown on the left here, with her sisters
Ina (1849–1930) and Edith (1854–1876) and brother,
Harry Liddell (1847–1911), was the inspiration for the
character of Alice in the book.

Lewis Carroll
Self-portrait
Albumen print, 1857
140 x 117mm
NPG P7(26)

Charles Dodgson (1832–98), better known as Lewis
Carroll, was a mathematics tutor at Christ Church,
Oxford. This photograph, dated 2 June 1857, is generally
assumed to be a self-portrait, although it may have
been taken by Reginald Southey, a fellow student who
encouraged Dodgson's early interest in photography.
Although always fascinated by its techniques, Dodgson
saw photography primarily as a means of expressing
himself artistically and often signed his prints 'from
the Artist'.

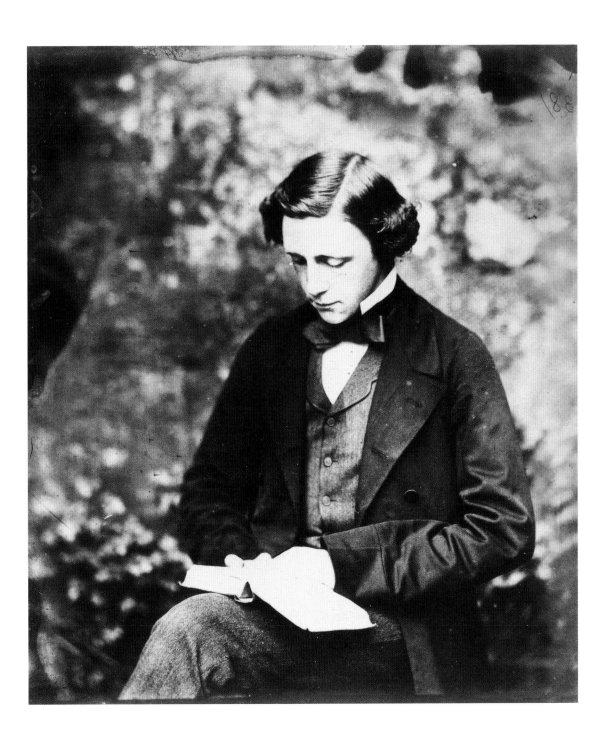

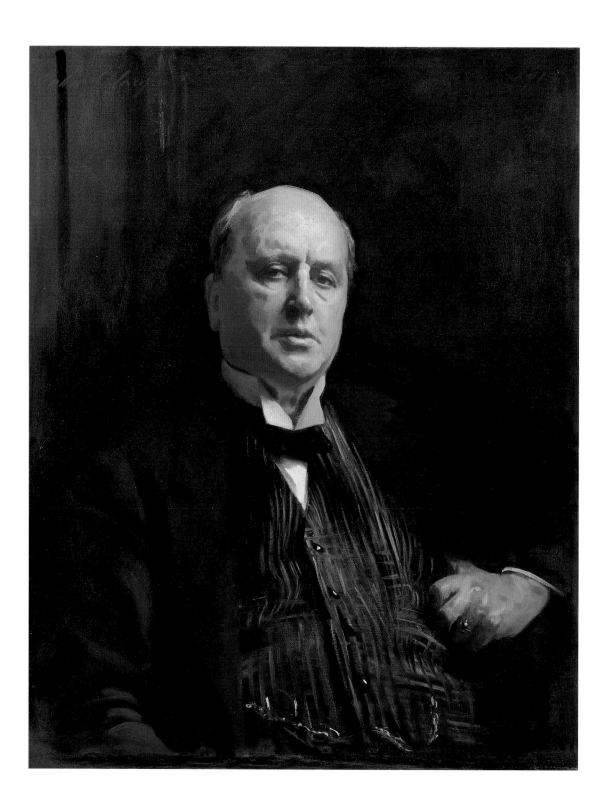

Robert Louis Stevenson
Sir William Blake Richmond (1842–1921)
Oil on canvas, 1886
737 x 559mm
NPG 1028

Robert Louis Stevenson (1850–94) wrote stories
and essays that are remarkable for their dramatic
realisation, such as *Treasure Island* (1883), *The Strange
Case of Dr Jekyll and Mr Hyde* (1886) and *Kidnapped*
(1886). This portrait was painted in one sitting, at the
artist's house, on a hot afternoon in August 1886 amid
a jovial company including Sidney Colvin, Edward
Burne-Jones and Burne-Jones's daughter, Margaret.
Margaret recalled their lively conversation: 'They
discussed suicide; compared notes as to their feelings
towards policemen; told ghost stories; and most of
the time Mr Richmond painted, and Mr Stevenson sat
easily talking, smoking, and drinking coffee.'

Henry James
John Singer Sargent (1856–1925)
Oil on canvas, 1913
851 x 673mm
NPG 1767

The American-born novelist Henry James (1843–1916)
settled in England, at Lamb House, Rye (now owned by
the National Trust), in 1898. By the time this portrait
was painted he was at the end of a career that had
seen the success of early novels, such as *Portrait of
a Lady* (1881), followed by the late masterpieces *The
Wings of the Dove* (1902) and *The Golden Bowl* (1904).
James commands a reputation as one of the greatest
writers in the English language, through works that
reflect the contrast between new American culture, and
European tradition. This portrait was commissioned
to celebrate James's seventieth birthday by a group of
269 subscribers organised by the American novelist
Edith Wharton, although ultimately Sargent, a fellow
American and friend, waived his fee. When it was
completed James pronounced the portrait to be 'a
living breathing likeness and a masterpiece of painting.'

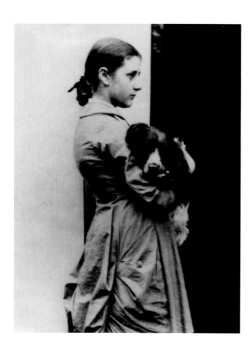

Beatrix Potter
Rupert Potter (1832–1914)
Photograph, 1889
169 x 220mm
Hill Top, Cumbria

The writer and artist Beatrix Potter (1866–1943) was the creator of Peter Rabbit, Jemima Puddle-Duck, Mrs Tiggy-Winkle and many other animal characters that have survived their Edwardian origins to become international classics of children's literature. Informally educated, Potter spent hours drawing in the Natural History Museum. Her children's stories, which she wrote and illustrated, began as letters to a child. The anthropomorphic characters display an unsentimental observation of human nature. They have achieved worldwide recognition, continuously published by Warne, and reproduced in ceramic, animated film and ballet. This photograph was taken by her father when she was a teenager. She is holding Spot, the family spaniel, outside Holehird, Windermere. Later, Potter farmed in the Lake District, bequeathing her house and land to the National Trust.

Virginia Woolf
George Charles Beresford (1864–1938)
Platinum print, 1902
152 x 108mm
NPG P221

A central figure of the Bloomsbury group, Virginia Woolf (1882–1941) is one of the major writers of English twentieth-century fiction, and a pioneer of the 'stream of consciousness' novel in works such as *Mrs Dalloway* (1925), *To the Lighthouse* (1927) and *The Waves* (1931). *A Room of One's Own* (1929) remains a classic in the canon of feminist writing. This photograph was taken in July 1902 when Virginia Woolf (Virginia Stephen as she was then, before her marriage to the writer and publisher Leonard Woolf) was just embarking on her career as a writer, and when the photographer Beresford had recently set up a commercial studio in Yeoman's Row, off the Brompton Road, London. The Woolfs' country home, Monk's House in Sussex, is owned by the National Trust.

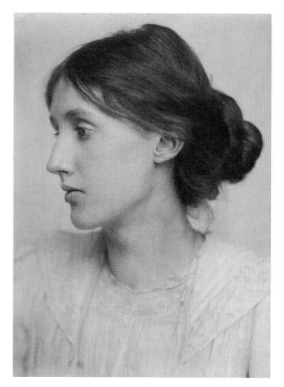

H.G. Wells
Alvin Langdon Coburn (1882–1966)
Photogravure, 1905
202 x 160mm
NPG Ax7773

H.G. Wells (1866–1946) was a writer and social
commentator and author of science-based futuristic
novels, such as *The Time Machine* (1895) and *The
Shape of Things to Come* (1933), which predicted air
warfare and the atomic bomb. Other works include
socialist pamphlets, educational tracts and loosely
autobiographical novels such as *The History of Mr Polly*
(1910). Wells spent part of his childhood at Uppark
in Sussex, an eighteenth-century house (now owned
by the National Trust), where his mother was the
housekeeper.

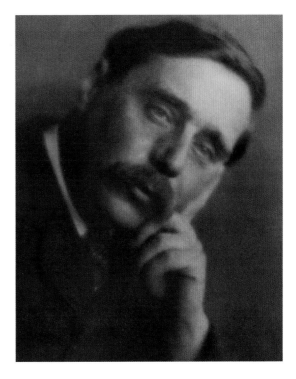

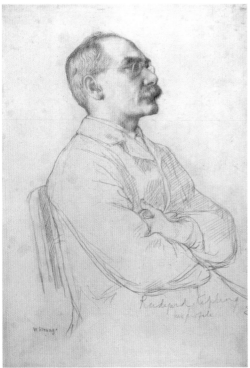

Rudyard Kipling
William Strang (1859–1921)
Pencil, *c*.1898
318 x 222mm
NPG 2919

Rudyard Kipling (1865–1936) was born in Bombay
and after an English education he returned to India to
work for the *Civil and Military Gazette* in Lahore. His
books, *Plain Tales from the Hills* (1887), *The Jungle Book*
(1894) and *Kim* (1901) among them, show Kipling
to be unequalled as an observer of the Raj and as a
commentator on the duties and obligations of empire.
Later in life he settled at Bateman's, a seventeenth-
century house in Sussex that is now owned by the
National Trust. Here Kipling drew inspiration for *Puck
of Pook's Hill* (1906) and *Rewards and Fairies* (1910),
as well as some of his finest late stories. Long out of
favour because of the imperialist themes in his work,
Kipling is now recognised as one of the major literary
talents of his time.

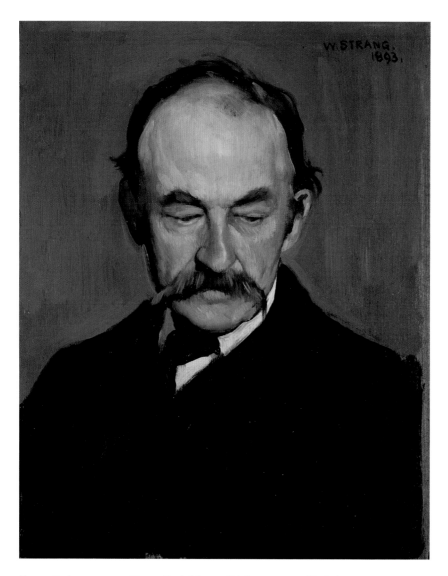

Thomas Hardy
William Strang (1859–1921)
Oil on panel, 1893
432 x 381mm
NPG 2929

Thomas Hardy (1840–1928) is known as one of the last great novelists of the nineteenth century. His writing is both visionary and naturalistic and his characters play out their lives against a rural landscape, often set in his native Dorset. Among his major works are *Far from the Madding Crowd* (1874), *The Return of the Native* (1878), *The Woodlanders* (1887), *Tess of the D'Urbervilles* (1891) and *Jude the Obscure* (1896). The painter William Rothenstein described Hardy as having 'a small dark bilberry eye which he cocked at you unexpectedly. He was so quiet and unassuming, he somehow put me in mind of a dew-pond on the Downs.' Hardy's Cottage, his birthplace, and Max Gate, where he lived from 1885 until his death, are now owned by the National Trust.

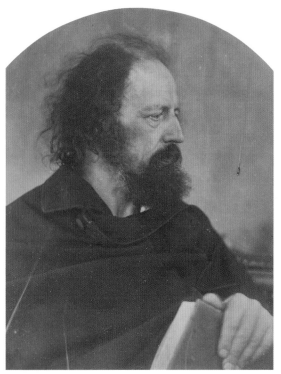

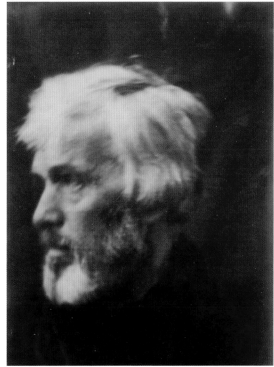

Alfred Tennyson, 1st Baron Tennyson
Julia Margaret Cameron (1815–79)
Albumen print, May 1865
249 x 201mm
NPG x18024

Alfred Lord Tennyson (1809–92), who succeeded
Wordsworth as Poet Laureate in 1851, won popular
recognition and celebrity with the publication of *In
Memoriam* (1850), 'The Charge of the Light Brigade'
(1854) and his Arthurian poems, *Idylls of the King*
(1859). Julia Margaret Cameron took up photography
in her late forties and was strongly influenced by
the mid-Victorian fascination for High Renaissance
painting and by the Romantic medievalism of the Pre-
Raphaelites. Cameron was a close friend and neighbour
of Tennyson on the Isle of Wight, and he was to be
one of her most important sources of inspiration, both
in her illustrations for his *Idylls of the King* and, more
generally, as a source for her style of poetic romance.
She photographed him on a number of occasions. This
was the portrait he liked best, writing under it, 'I prefer
the Dirty Monk to the others of me.'

Thomas Carlyle
Julia Margaret Cameron (1815–79)
Albumen print, printed in reverse, 1867
337 x 286mm
NPG P123

Julia Margaret Cameron photographed the historian
Thomas Carlyle (1795–1881) at Little Holland House,
'to which place,' she wrote, 'I had moved my Camera
for the sake of taking the great Carlyle.' This amazing
profile head of him as an old man, moving slightly in
front of the camera, is deliberately and convincingly
intended to make him look like an Old Testament
prophet. Carlyle himself did not particularly like it,
writing, 'It is as if suddenly the picture began to speak,
terrifically ugly and woe-begone, but has something of
a likeness – my candid opinion.' On the other hand,
Roger Fry, who was an early enthusiast for Cameron's
work, was eulogistic, writing, 'Neither Whistler
nor Watts come near to this in the breadth of the
conception, in the logic of the plastic evocations and
neither approach the poignancy of this revelation of
character.' It is possible that it was taken while Carlyle
was sitting for Watts' portrait. Carlyle's house in Cheyne
Row, London, is now owned by the National Trust.

Public life and empire

The present political system in Britain, with parliamentary parties and a centralised civil service, was established during the reigns of Victoria and Edward VII. The Reform Acts of 1832, 1867 and 1884 increased the electorate to include all male householders aged over twenty-one. Despite long and angry campaigns, no women had the parliamentary vote, but by the end of the period some were able to vote in local elections. Over much of the nineteenth century, Conservatives and Liberals alternated in government, with the Labour Party emerging in the 1900s.

For the first two decades of Victoria's reign the royal court dominated the upper classes of British society. The Queen and her consort were highly influential in cultural affairs, for example through Prince Albert's vision for the Great Exhibition of 1851. After his death in 1861 Victoria withdrew from public view and the monarchy declined in popular esteem, but her son, Edward VII, restored the pageantry that still attends royal events.

The British Empire flourished as a global power during Victoria's reign, and the role of protecting British interests worldwide grew alongside British industrial might. Colonial rule in territories such as Canada and Australia was extended to India, Malaya and West Africa, where careers in the Foreign and Colonial Service could bring reward and renown to the men involved. Military intervention took place in Afghanistan, the Crimea, India, Egypt and Africa, and campaign leaders became popular heroes. So too did adventurers who travelled to uncharted regions of Asia, Antarctica and Africa, following the example of the missionary and explorer David Livingstone.

Victorian society championed moral values of individualism, hard work and self-help. However, notions of religious duty and personal improvement encouraged social responsibility and philanthropy. Alongside the growth of labour organisations, vigorous reforms were initiated to improve industrial safety, protect children, provide better housing, alleviate poverty, discourage drunkenness and ensure animal welfare, laying the foundations for the twentieth-century welfare state, initiated by the Liberal government of 1906–14. Women, in particular, were active in these new campaigns. While many worked as unpaid volunteers, new professions, such as nursing, teaching and social work, offered opportunities for women. In politics, many were prominent behind the scenes as political hostesses, campaign organisers and educators.

Henry Fawcett and Dame Millicent Garrett Fawcett

Ford Madox Brown (1821–93)
Oil on canvas, 1872
1086 x 838mm
NPG 1603

Henry Fawcett (1833–84), who was blinded in a shooting accident in 1858, had a distinguished career as professor of political economy at Cambridge, and as a Member of Parliament. He was active in the passing of the 1867 Reform Bill and was particularly concerned with the position of women in employment. In this intimate portrait by Madox Brown, Fawcett is seen together with his wife, Millicent Garrett Fawcett (1847–1929), and appears to be dictating to her. An active campaigner for women's suffrage, Millicent joined the first women's suffrage committee in 1867, the year of her marriage. In 1897 she became president of the influential National Union of Women's Suffrage Societies, which opposed the more militant suffragettes active in the early 1900s. She retired from the presidency after women gained their first, restricted, voting rights in 1918.

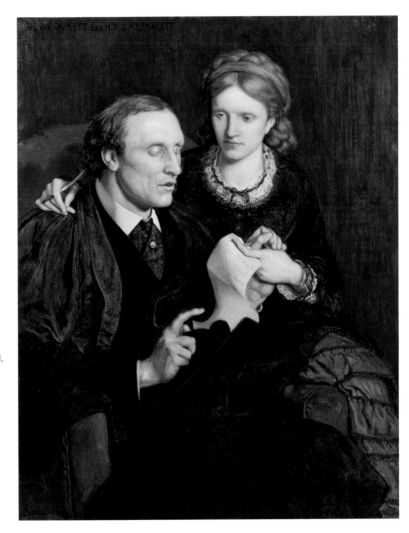

Queen Victoria
Sir George Hayter (1792–1871)
Oil on canvas, 1863 (1838)
2858 x 1790mm
NPG 1250

Queen Victoria (1819–1901) ascended
to the throne at the age of eighteen on
the death of her uncle, William IV, in
1837 and was crowned on 28 June 1838.
She wrote in her journal on the day of
her Coronation: 'I really cannot say how
proud I feel to be the Queen of such
a Nation', and some of this idealism
is conveyed in Hayter's Coronation
portrait. Victoria described a small
version of this portrait, which Hayter
painted for her private apartments, as
'excessively like and beautifully painted'.
This version is an autograph replica of
an original of 1838. Victoria's reign was
the longest in British history and she
influenced, to a considerable extent,
the foreign and domestic policies
of successive governments and the
attitudes and manners of her people.

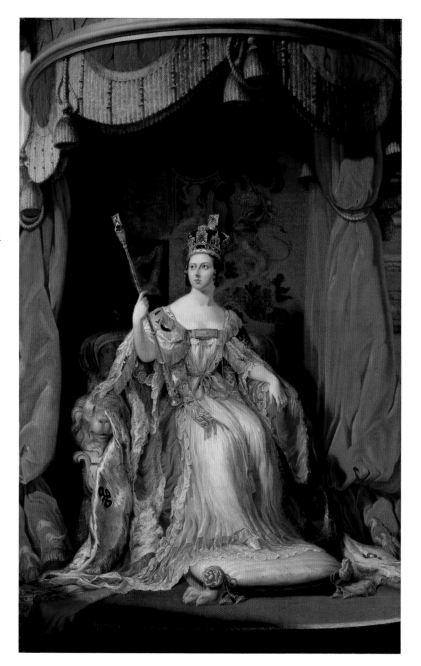

Prince Albert
Franz Xaver Winterhalter (1805–73)
Oil on canvas, 1867 (1859)
2413 x 1568mm
NPG 237

The second son of Ernest, Duke of Saxe-Coburg-Gotha, Albert of Saxe-Coburg-Gotha (1819–61) married his cousin, Queen Victoria, in 1840 and played an influential role in British public life. Noted as a patron of the arts, Prince Albert was largely responsible for the Great Exhibition of 1851. The original version of this portrait, showing Prince Albert wearing the Star of the Garter and the uniform of the Rifle Brigade, was one of the last portraits to be painted of him before his premature death from typhoid in 1861. This autograph replica was commissioned for the National Portrait Gallery by Queen Victoria.

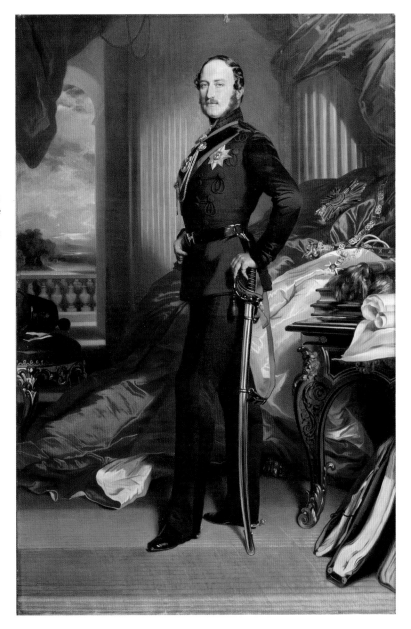

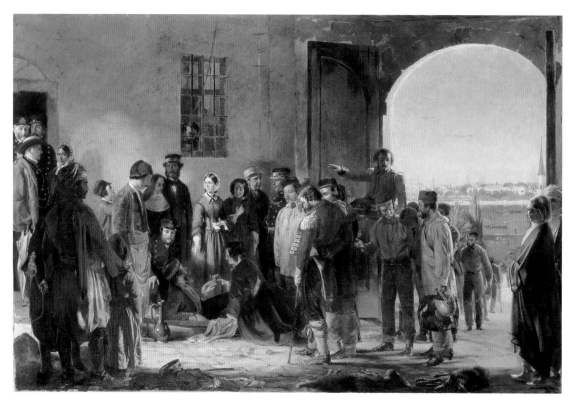

*The Mission of Mercy: Florence Nightingale Receiving
the Wounded at Scutari*
Jerry Barrett (1824–1906)
Oil on canvas, 1857
1410 x 2127mm
NPG 6202

Few people came out of the Crimean War with credit,
but Florence Nightingale (1820–1910), who campaigned
on behalf of the sick and wounded British soldiers,
was made a national hero for her achievements. In
October 1854 she had travelled to Scutari, a suburb
of Constantinople (Istanbul), where she transformed
the appalling conditions at the Barrack Hospital and
laid the foundations for lasting reforms in nursing
care. Clearly highlighted near the centre of Barrett's
painting, Nightingale is shown receiving casualties in the
quadrangle of the hospital. The artist has shown himself
looking out from the window above her.

Mary Seacole
Albert Charles Challen (1847–81)
Oil on panel, 1869
240 x 180mm
NPG 6856

This is the only known painting of Mary Seacole
(1805–81), a nurse in the Crimean War and a woman
of great courage and humanitarianism, who overcame
considerable obstacles to pursue her career. Born in
Jamaica, Seacole did not have a conventional nurse's
training. She learned alongside her mother – a healer
and specialist in traditional herbal medicine. Although
not officially decorated for her war services she wore
with pride replicas of medals presented by the allied
powers. When the war ended, Mary returned to
England, destitute and bankrupt. She received support
from many influential people and published her
autobiography. This remarkable portrait only came to
light in 2002, and very little is known about the artist
or the circumstances in which it was painted.

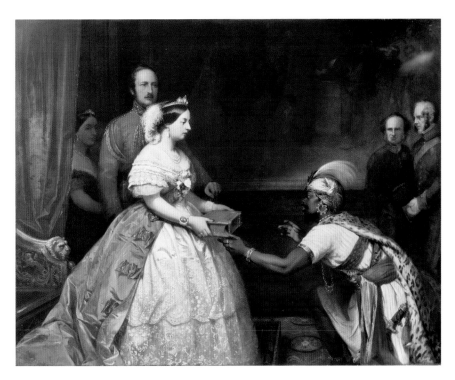

The Secret of England's Greatness
(Queen Victoria presenting a Bible in the Audience Chamber at Windsor)
Thomas Jones Barker (1815–82)
Oil on canvas, c.1863
1676 x 2138mm
NPG 4969

This group epitomises the Victorian concept of the British Empire, which was seen as conferring the benefits of European civilisation, and Christianity in particular, on the peoples over whom it ruled. Prince Albert (1819–61) stands to the left of Queen Victoria (1819–1901), while on the left in the background is the Duchess of Wellington and on the right are the statesmen Lord Palmerston (1784–1865) and Lord John Russell (1792–1878). In the foreground Victoria presents a Bible to an African envoy. Although the portraits of the British sitters are accurate, as is the setting of the audience chamber at Windsor, including Benjamin West's large painting of *The Institution of the Order of the Garter*, carefully indicated in the background, no actual occasion for the picture's subject has been identified. It was engraved under the title *The Bible: The Secret of England's Greatness* in 1864, indicating that it was conceived to convey the key role of Christian belief in the Empire.

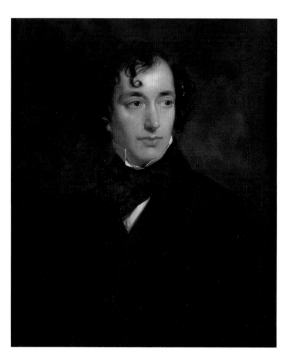

Benjamin Disraeli
Sir Francis Grant (1803–78)
Oil on canvas, c.1852
950 x 830mm
Hughenden Manor, Buckinghamshire

Benjamin Disraeli (1804–81) is known as one of the greatest statesmen of his age. He first made his mark as a flamboyant literary prodigy and gradually asserted his influence on the Conservative Party through his outstanding abilities as a politician and orator. He became Prime Minister in 1868, and guided the Second Reform Bill through Parliament. His diplomatic triumphs included the purchase of the Suez Canal and the Congress of Berlin. This portrait came about through a joint connection of the artist and sitter, the Marquis of Granby: Disraeli recounted that 'Frank Grant has asked, thro' Granby, to paint my portrait. He will charge nothing. He does it for the sale of the engraving.' Disraeli's home, Hughenden Manor, where this portrait hangs over the fireplace in the library, is owned by the National Trust.

William Ewart Gladstone
Sir John Everett Millais (1829–96)
Oil on canvas, 1879
1257 x 914mm
NPG 3637

William Ewart Gladstone (1809–98), the grand old man of British politics, was leader of the Liberal Party and Prime Minister in four governments from 1868 to 1894. He was responsible for major reforms in every sphere of national life, for the development of imperial foreign policy and for dividing the party on the issue of Irish Home Rule. Gladstone, a considerable scholar and author, stamped his moral authority on the politics of his time. He sat for five, one-hour sittings for this portrait, remarking in his diary of 6 July 1879 that Millais' 'ardour and energy about his picture inspire a strong sympathy.'

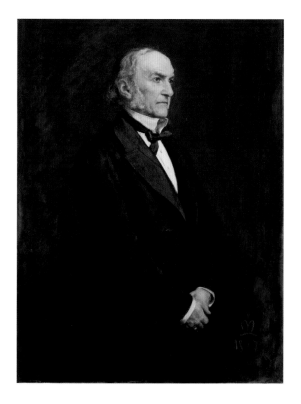

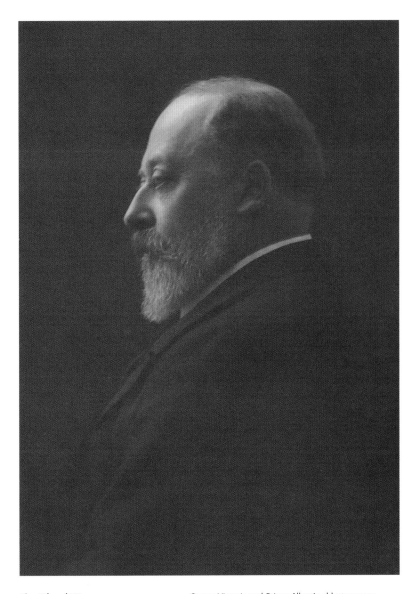

King Edward VII
Baron Adolf de Meyer (1868–1946)
Sepia planiotype, 1904
244 x 162mm
NPG P720

Queen Victoria and Prince Albert's eldest son was named after his father and known as 'Bertie'. In his youth, the future King Edward VII (1841–1910) rebelled against the strict academic education planned by his father. Queen Victoria denied her son any public responsibilities, and he devoted his sixty years as Prince of Wales to sport and high society. His reign from 1901 saw a new era of prosperity, expansion and pageantry that restored his popularity. He married Princess Alexandra of Denmark in 1863, and their descendants include Queen Elizabeth II and King Harald of Norway.

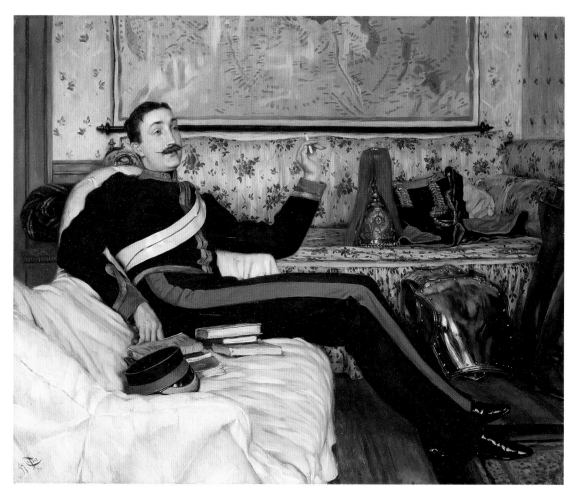

Frederick Burnaby
James Jacques Tissot (1836–1902)
Oil on panel, 1870
495 x 597mm
NPG 2642

An officer of the Royal Horse Guards with a gift for
languages and a penchant for travel and adventure,
Frederick Burnaby (1842–85) became renowned for both
his exploits and his writings about them. *A Ride to Khiva*
(1876), the narrative of a journey on horseback across
three thousand miles of the Russian steppes in winter,
and *On Horseback through Asia Minor* (1877), which
described a tour during which he fought on behalf of the
Turks against the Russians, were both best-sellers. A tall
figure, nearly two metres in height, he was reputed to
be the strongest man in the British army and was said
to have once carried a pony under one arm. He was
painted by Tissot in his uniform as a captain in the 3rd
Household Cavalry.

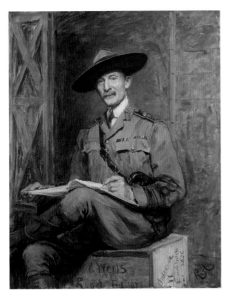

Robert Baden-Powell, 1st Baron Baden-Powell
Gwen John (1876–1939)
Oil on canvas, c.1900
610 x 378mm
NPG 5991

Army officer Robert Baden-Powell (1857–1941) took
part in the Zululand (1888), Ashanti and Matabeleland
(both 1896) campaigns in South Africa. During the
Boer War he held Mafeking under siege for 217 days
until relieved. In 1910 he retired from the army in order
to devote himself to the Scouting movement, the
foundation of which was initiated by the publication
of his book *Scouting for Boys* (1908). The uniform he
is wearing in this portrait is one that he designed
himself for the South African Constabulary; the hat
was later adapted for the Boy Scouts. Brownsea Island
in Poole Harbour, Dorset, the location of the first Boy
Scout camp in August 1907, is now owned by the
National Trust.

**Horatio Herbert Kitchener,
1st Earl Kitchener of Khartoum**
Sir Hubert von Herkomer (1849–1914) and
Frederick Goodall (1822–1904)
Oil on canvas, 1890
1397 x 1092mm
NPG 1782

Horatio Herbert Kitchener (1850–1916) was the
epitome of the Victorian imperialist general. He
led the unsuccessful expedition to rescue General
Gordon in Khartoum, and subsequently commanded
armies in Egypt and the Sudan. His reputation was
later enhanced by his victories during the Boer War.
Kitchener made the transition from active command in
the field to military administration with great aplomb.
It was he who was chiefly responsible for converting
the small British army into a military machine of
three million men during the early years of the First
World War, and is remembered for his slogan 'Your
country needs you'. This portrait by Herkomer and
Goodall was painted shortly before he was made Sirdar
(Commander-in-Chief) of the Egyptian army. It shows
Kitchener, wearing the drill khakis of a Colonel of the
Royal Engineers, standing before Cairo.

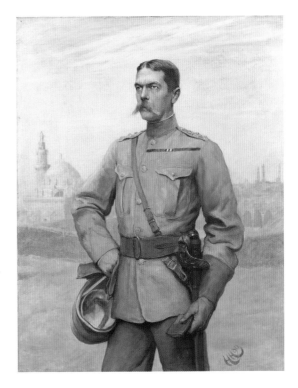

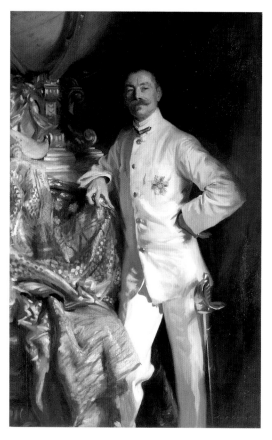

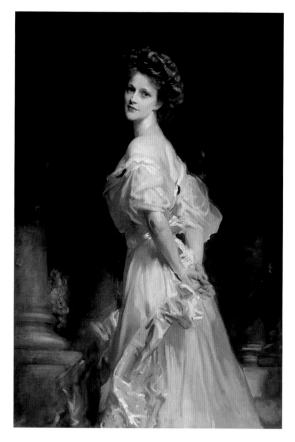

Sir Frank Swettenham
John Singer Sargent (1856–1925)
Oil on canvas, 1904
1708 x 1105mm
NPG 4837

A portrait of the colonial administrator Frank
Swettenham (1850–1946) was commissioned in
1903 from the leading society portraitist of the
time, the American artist Sargent, by the Malay
Straits Association of London. This portrait began
as a copy of an earlier full-length portrait by one of
Sargent's copyists, but Sargent took over the painting
and Swettenham gave fresh sittings. He is shown
surrounded by accessories evoking his career: a huge
globe just visible in the top left-hand corner hovers over
a chair draped with the magnificent South East Asian
textiles that he collected. Swettenham wears his white
uniform and adopts an elegant, Van Dyckian pose,
leaning against the chair and gripping it with his right
hand, his claw-like fingers providing a note of tension.

Nancy Astor
John Singer Sargent (1856–1925)
Oil on canvas, 1908–9
1760 x 1260mm
Cliveden, Buckinghamshire

Nancy Astor (1879–1964) was the first female Member
of Parliament. Born in the United States of America she
moved to England in 1905. After marrying her second
husband, Waldorf Astor, in 1906, she became a society
hostess and socialite. When Waldorf Astor acceded to
his father's viscountcy, Lady Astor won her husband's
former seat of Plymouth in Parliament and worked
to further many causes. She had a turbulent political
career often fraught with controversy, but is best
remembered for her sometimes acerbic wit. Her home
and gardens at Cliveden are owned by the National
Trust. The pose for this portrait was adapted by Sargent
from Romney's portrait *Mrs Jordan as 'Peggy' in 'The
Country Girl'* at Waddesdon Manor, which is also a
National Trust property.

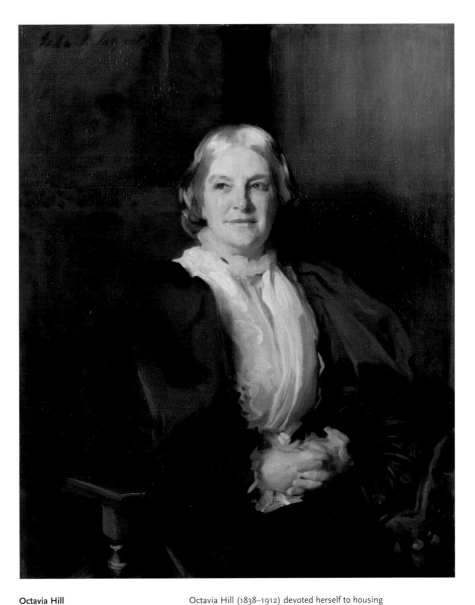

Octavia Hill
John Singer Sargent (1856–1925)
Oil on canvas, 1898
1010 x 775mm
NPG 1746

Octavia Hill (1838–1912) devoted herself to housing reform and to supervising the building and management of working-class dwellings. She was influenced by Christian Socialism and encouraged by John Ruskin in her schemes for improving the housing of the poor. She was also widely involved in other charitable activities, especially parks and open spaces and was a co-founder of the National Trust. This portrait was commissioned from Sargent by her friends and was given to Hill on her sixtieth birthday.

National Trust properties to visit

The National Trust is a charity with a love for preserving historic places and spaces across England, Wales and Northern Ireland. The Trust protects over 350 historic houses and gardens, 1,100km of coastline, 254,000 hectares of countryside and six World Heritage sites – for ever, for everyone.

Many of the portraits featured in this book still hang in the historic settings for which they were commissioned.

To find out when properties are open to visit, admission prices, membership and much else besides, please visit nationaltrust.org.uk or telephone 0844 800 1895.

SOUTH EAST

Bateman's
Burwash, East Sussex
TN19 7DS
T: 01435 882302
Jacobean house, home of writer Rudyard Kipling.

Carlyle's House
Chelsea, London SW3 5HL
T: 020 7352 7087
Home of Thomas and Jane Carlyle, Victorian literary couple.

Lamb House
Rye, East Sussex TN31 7ES
T: 01580 762334
Fine, brick-fronted house owned by writer Henry James.

Monk's House
Lewes, East Sussex BN7 3HF
T: 01323 870001
Country retreat of novelist Virginia Woolf.

Red House
Bexleyheath, London
DA6 8JF (booked tours only)
T: 020 8304 9878
Iconic Arts and Crafts home of William Morris – writer, craftsman and socialist.

South Foreland Lighthouse
Dover, Kent CT15 6HP
T: 01304 852463
Fascinating and distinctive Victorian lighthouse linked to Michael Faraday.

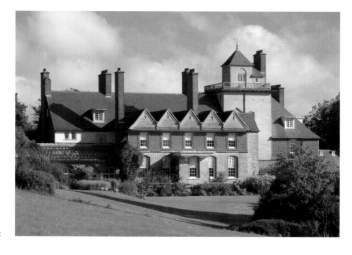

Standen, West Sussex

Smallhythe

Tenterden, Kent TN30 7NG
T: 01580 762334
Actress Ellen Terry's early
sixteenth-century house
and cottage gardens.

Standen

East Grinstead, West Sussex
RH19 4NE
T: 01342 323029
Late Victorian family home
with Arts and Crafts interiors
designed by Philip Webb and
William Morris.

Uppark

Petersfield, West Sussex
GU31 5QR
T: 01730 825857
Tranquil and intimate
eighteenth-century house,
where H.G. Wells' mother
was housekeeper.

Claydon

Middle Claydon,
Buckinghamshire MK18 2EY
T: 01494 755561
Eighteenth-century English
interiors in an idyllic setting;
family connection to Florence
Nightingale.

Cliveden

Maidenhead,
Buckinghamshire SL6 0JA
T: 01494 755562
Formal gardens and hotel
overlooking the Thames; home
to Waldorf and Nancy Astor.

Hughenden Manor

High Wycombe,
Buckinghamshire HP14 4LA
T: 01494 755565
Country home of the Victorian
statesman Benjamin Disraeli.

Uppark, West Sussex

Shaw's Corner

Ayot St Lawrence,
Hertfordshire AL6 9BX
T: 01438 829221
Country home of Irish
playwright George Bernard
Shaw.

Hughenden Manor, Buckinghamshire

Brownsea Island
Poole Harbour, Dorset
BH13 7EE
T: 01202 707744
Island in Poole Harbour,
famed for its wildlife and
being the birthplace of
the Scouting and Guiding
movements founded by Robert
Baden-Powell.

Hardy's Cottage
Dorchester, Dorset DT2 8QJ
T: 01305 262366
Birthplace of novelist and poet
Thomas Hardy.

Lacock
Chippenham, Wiltshire
SN15 2LG
T: 01249 730459
Former medieval abbey
and home to William Henry
Fox Talbot, pioneer of
photography.

Max Gate
Dorchester, Dorset DT1 2AB
T: 01297 489481
House designed and lived in by
Thomas Hardy from 1885 until
his death in 1928.

Wightwick Manor
Wolverhampton,
West Midlands WV6 8EE
T: 01902 761400
Victorian manor house with
William Morris interiors and
colourful garden.

NORTH AND NORTH EAST

Belton House
Grantham, Lincolnshire
NG32 2LS
T: 01476 566116
Seventeenth-century country
house with magnificent
interiors, beautiful gardens
and extensive parkland.

Cragside, Northumberland

Cragside
Morpeth, Northumberland
NE65 7PX
T: 01669 620333
Home of Lord Armstrong,
Victorian inventor and
landscape genius.

Hilltop
Hawkshead, Cumbria
LA22 0LF
T: 01539 436269
Tiny seventeeth-century
farmhouse where Beatrix
Potter wrote many of her
famous children's stories.

Lacock, Wiltshire

National Portrait Gallery and Bodelwyddan Castle

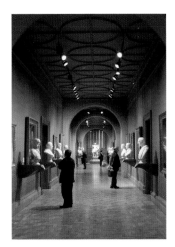

Statesmen's Gallery, National Portrait Gallery, London

National Portrait Gallery
London WC2H 0HE
T: 020 7306 0055
W: npg.org.uk
The National Portrait Gallery was founded in 1856 'to promote through the medium of portraits the appreciation of men and women who have made and are making British culture.' Victorian and Edwardian portraits from its extensive Collection are displayed on the first floor. The Statesmen's Gallery (left) features three-quarter-length oil paintings and marble busts of figures from politics and public life to represent Victorian power.

The National Portrait Gallery has a number of regional partners in whose properties works from the Collection are displayed.

Bodelwyddan Castle
Denbigshire, North Wales
LL18 5UY
T: 01745 584060
W: bodelwyddan-castle.co.uk
Many of the National Portrait Gallery's most significant portraits from this period can be seen on display at Bodelwyddan Castle one of the Gallery's regional partners. Works from the Collection held here include portraits from George Frederic Watts' 'Hall of Fame' series (below) and paintings by the Pre-Raphaelite artists Ford Madox Brown and William Holman Hunt.

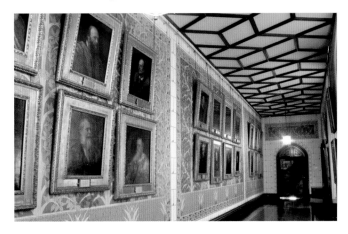

George Frederic Watts' 'Hall of Fame' at Bodelwyddan Castle, North Wales

Index of artists and sitters